THE ART OF
BOTANICAL & BIRD
ILLUSTRATION

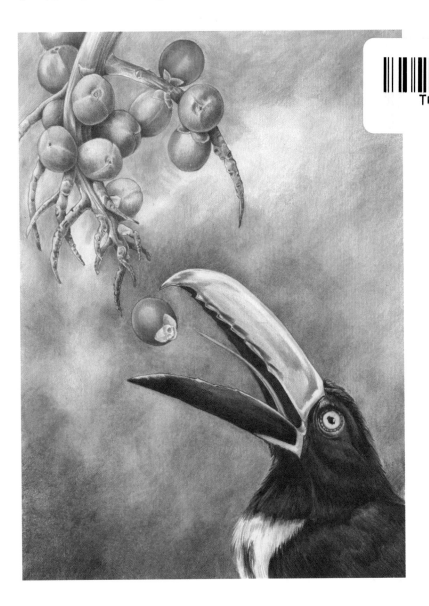

MINDY LIGHTHIPE

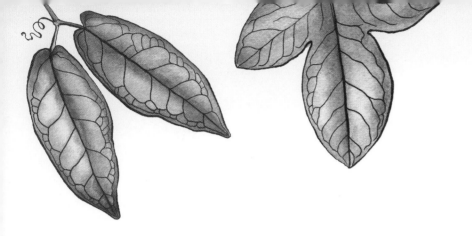

Quarto.com • WalterFoster.com

First Published in 2017 by Walter Foster Publishing, an imprint of The Quarto Group.
100 Cummings Center, Suite 265D, Beverly, MA 01915, USA.
T (978) 282-9590 **F** (978) 283-2742

Walter Foster Publishing titles are also available at discount for retail, wholesale, promotional, and bulk purchase. For details, contact the Special Sales Manager by email at specialsales@quarto.com or by mail at The Quarto Group, Attn: Special Sales Manager, 100 Cummings Center, Suite 265D, Beverly, MA 01915, USA.

ISBN: 978-1-63322-378-3

Acquiring & Project Editor: Stephanie Carbajal
Page Layout: Jacqui Caulton

Printed in China
10 9 8 7 6

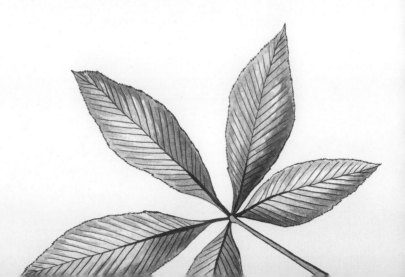

Table of Contents

Getting
Started

Introduction

I grew up as an only child and always loved to draw. My parents taught me at a young age to appreciate, respect, and love nature. I started learning about nature at summer camp in Pennsylvania, and being exposed to nature made me passionate about plants, animals, and insects. I decided early that I was going to be "an Artist" when I grew up.

My grandmother was a Girl Scouts leader, and she had a vast wealth of knowledge about the plant world. I was so amazed that she seemed to know the names of all the plants in her garden and on our walks in the woods. I thought I would never know as much as she did.

As a young college student, I was an art major and focused my studies on textiles. I learned to spin yarn on a spinning wheel, grow plants for natural dyeing, and weave fabric on an old-fashioned floor loom. For the first 20 years of my career, I worked as a production spinner and handweaver. I sold my handwoven clothing at art festivals and specialty stores around the United States. It was a labor of love, but after 20 years I wanted to devote my time to drawing and painting nature.

I enrolled in and completed a 200-hour certification in botanical illustration at the New York Botanical Garden. The program launched a new career that continues to feed a lifelong passion. Drawing plants has made me a gardener as well as a conservationist. Drawing nature requires acute observation. The more I see, the more I learn, and the more I want to convey in my paintings. I still feel like the child I was once was. The wonder of nature is all around, and I want to see it, experience it, and share it through my paintings. It is my hope that through my paintings I inspire people to love nature and want to protect it.

I have had the wonderful opportunity in my career to teach people how to draw. By studying with people like Betty Edwards, I learned that drawing is a skill—and not all about having talent. Taking a subject and breaking it down step by step is the best way to learn how to draw. Whatever your story or background or artistic experience, you can learn how to see and illustrate the natural world around you.

In this book I introduce you to many styles and applications of drawing plant and birds. Many artists and art teachers work in a specific medium. I do not consider myself a "purist." I enjoy working in a variety of mediums. I think combining different techniques can be challenging, rewarding, and fun. In this book I hope to inspire you not to be afraid to experiment. There are many ways to do any one thing, and the challenge is to find what works best for you. I hope you will be inspired to draw the beauty of nature!

Introduction to Drawing Supplies

Learning to draw and paint is a combination of mastering techniques and using the correct materials. Understanding the basics can prevent a lot of frustration later.

Selecting Drawing Paper

Paper Texture

Drawing paper is one of the most important aspects for hassle-free drawing. To create a wide range of tone (areas of light to dark) in a drawing, artists build up graphite in layers. The surface of the paper must have a "tooth," or texture. The tooth of the paper creates hills and valleys that collect graphite. As layers are applied to the paper, it becomes darker. If the paper is too smooth, the graphite has nowhere to settle into and simply sits on top. The paper saturates quickly, and the result is a flat, monochromatic appearance. When the paper has a moderate amount of tooth, the results are three-dimensional and detailed. A lot of tooth results in a rough drawing with minimal detail. Paper is also available recycled, bright white, natural, and colored. I prefer to work with Strathmore® drawing paper, medium-texture recycled.

Paper Thickness

All art papers, whether made for drawing, watercolor, colored pencil, or pastel, are classified by the thickness, or "weight," of the paper. Below is a basic listing of how papers are categorized by weight and what they are best suited for.

- **25 lb.** (approx. 40 gsm): This is the thinnest paper available and is usually found as tracing paper.
- **30–35 lb.** (approx. 45–50 gsm): This is the typical weight of "scrap" or newsprint papers that tear easily.
- **50–80 lb.** (approx. 75–130 gsm): This range is mostly used as sketching or practice paper. It is thick enough to work on with pencils, charcoal, or pastels, but usually too thin for ink, watercolor, or markers. This paper has no ability to hold liquid and often bleeds through to the other side.
- **90–110 lb.** (approx. 180–260 gsm): This is a good all-around weight for drawing paper to use with graphite, colored pencil, charcoal, pastel, and light applications of fluid mediums, such as ink.
- **140–300 lb.** (approx. 300–640 gsm): These weights are most often used for painting, rather than drawing.

Acid-Free

I recommend choosing, whenever possible, a paper that is listed as "acid-free" by the manufacturer. This kind of paper is made from cellulose pulp, which comes from wood, cotton, and other natural resources. Within the natural order of these plant-based materials, the pH level is on the acidic side. Acid breaks down paper over time, turning it yellow and disintegrating it. Acid-free papers have gone through a process that removes the acid. The paper is "neutralized" and is considered "archival," which means it won't yellow, disintegrate, or fade over time. This will protect your drawings for a very long time.

Tracing Papers

Tracing paper is an inexpensive, translucent paper. It yellows quickly, tears easily, and is usually not acid-free. Tracing vellum is a heavier-weight tracing paper that is often available acid-free. I prefer tracing vellum, but the cost may be prohibitive, since it is more expensive than tracing paper. I use tracing vellum to create my compositions, correct drawing errors, and protect paintings during and after the painting process. All my compositions are created and finalized in multiple "layers" on tracing vellum, and I save them in a folder as an archive of the elements of the painting. I can also reuse the drawings in future compositions.

Watercolor Papers

Watercolor paper is available in large sheets and blocks in different dimensions. There are three basic textures: hot-pressed, cold-pressed, and rough. Hot-pressed has the smoothest surface. Cold-pressed has a slightly bumpy texture. Rough, as the name implies, has the coarsest texture. The color of the paper can be white, off-white, or bright white. For beginners, I recommend cold-pressed, because it is easier to work on. Hot-pressed paper is more challenging, but the smooth surface allows for more details.

You can use watercolor paper for all mediums, not just watercolor. I use it with pencil, colored pencil, watercolor pencils, watercolor, gouache, and pastels. I prefer working on hot-pressed, 300-lb. paper, because it doesn't warp or buckle. The heavier the paper, the more expensive it is. There are several online art supply retailers that offer trial packages of paper. This is an affordable way to purchase small quantities of paper to experiment with to find what works best for you.

Specialty Papers

One of my favorite papers for use with colored pencil isn't actually paper, but a type of plastic film called Mylar®. I like to work with Grafix® Dura-Lar® double-frosted Mylar. Grafix makes a variety of plastic "drafting" films, but my favorite is the 5-mil double-frosted Mylar. It comes in pads and looks very much like tracing paper, but it is thicker and doesn't tear, rip, or yellow. It's also acid-free. The surface of the paper has a "frosted," semi-opaque texture on both sides, which allows layering of colored pencil on both sides. I like the way the color lays down on the surface. The final appearance looks more like a painting than a colored pencil drawing. The microscopic tooth of the paper allows for fine details. You can also use decorative papers behind the drawings for decorative and collage purposes.

Graphite

Starting out is as easy as using a simple drawing pencil. What's the difference between a drawing pencil and a regular writing pencil? The answer is in the hardness or softness of the lead. H pencils are hard, and B pencils are soft. The higher the number that accompanies the letter, the harder or softer the lead is. F and HB, which is the lead of a standard No. 2 pencil, are in the middle of the range. Look for manufacturers that create pencils using high-quality lead.

Types of Pencils

Many manufacturers offer a wide range of drawing pencils. Look for pencils that deliver consistent, even coverage. Not all pencils or manufacturers are the same, so it's important to experiment with different brands to find what works best for you.

Pencil hardness scale

HARDER		SOFTER	
8B	4B	HB	4H

Pictured here are gradations of 8B, 4B, HB, and 4H leads over medium drawing paper, allowing you to see differences in stroke quality and darkness.

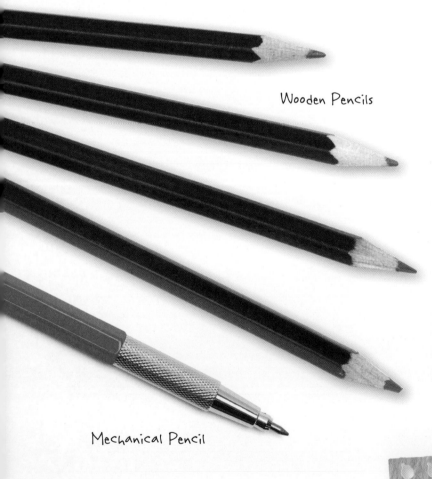

Wooden Pencils

Mechanical Pencil

Pencils are available in two forms: wooden and mechanical. Wooden pencils come in sets or can be purchased individually and can be sharpened with a standard pencil sharpener. Regular mechanical pencils that you find at any office supply store only take one kind of lead and don't require sharpening—they are great for sketching in the field. Mechanical pencils from the art store come in various leads and require a special pencil sharpener. The point on this pencil is the best for getting sharp, crisp, well-defined details. You can purchase a single lead holder and interchange different lead weights.

The goal is to develop your own style. Some artists are bold and heavy-handed, while others are delicate and subtle.

Paper Stumps or Tortillions

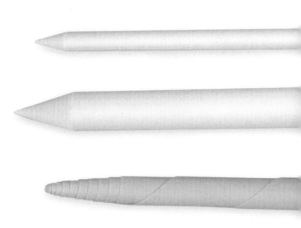

"Tortillion" is a fancy name for a paper stump. This cylindrical drawing tool, tapered at one or both ends, is made of rolled paper. You can use them to blend, smear, and apply graphite, pastel, and charcoal on paper. There are two kinds of paper stumps: hollow and solid. Hollow stumps are inexpensive and disposable. Solid stumps can be used over and over again—just sharpen with a piece of fine sandpaper. Paper stumps come in a variety of sizes.

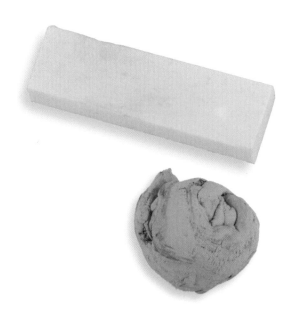

Erasers

I recommend two types of erasers: kneaded and plastic. A kneaded eraser lifts tone without removing the entire drawing. To clean and keep it pliable, simply pull it apart and "knead." Kneaded erasers can be used with graphite or colored pencil. I recommend having one designated for graphite and one for colored pencil.

Plastic erasers come in a variety of sizes and shapes and are usually white. This kind of eraser can be used on all kinds of papers and plastic surfaces, such as Mylar, without damaging the paper.

Eraser Shield

This tiny flat piece of metal is a great asset in protecting areas adjacent to where you want to erase something. It's available at office and art supply stores.

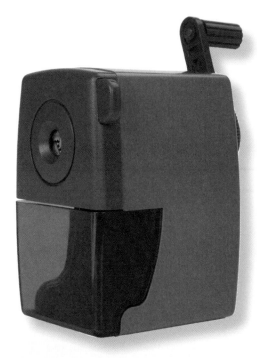

Pencil Sharpener

Maintaining a sharp point while working in graphite or colored pencil is essential for getting crisp details. Small handheld sharpeners typically don't get the point quite sharp enough. Electric pencil sharpeners produce a great point, but they are more expensive and tend to "eat" the pencil. I prefer to use an affordable, handheld, desktop pencil sharpener.

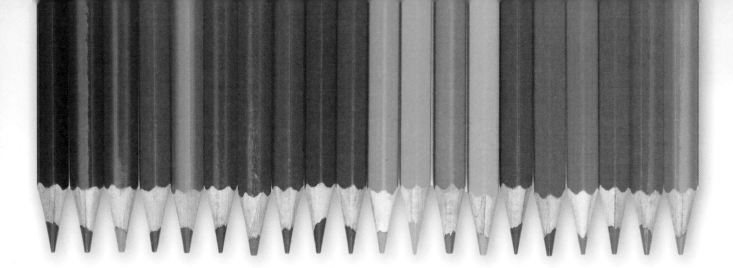

Colored Pencils

Colored pencils are made from pigments that are mixed with fillers and wax or oil. There are many colored pencil manufacturers. I highly recommend beginning with a basic, minimal assortment of colors purchased individually. Experiment to find the brand you like best. Some are creamy, waxy, soft, and brilliantly colored, such as Premier® Colored Pencils by Prismacolor®. Others, such as Prismacolor's Verithin®, are not as vibrant, and the lead is harder and doesn't break when pressed into the paper. Softer pencils are great for covering large areas evenly, and harder pencils work well for outlining and defining edges and details.

Watercolor Pencils

Watercolor pencils offer the control of colored pencils with the look of fluid watercolor paint. The application is the same as wax- or oil-based colored pencils, but you can add water any time, which intensifies and spreads the pigment. Once dry, subsequent layers of watercolor pencil can be added, either dry or wet. You can also add wax- or oil-based colored pencils on top as a final layer.

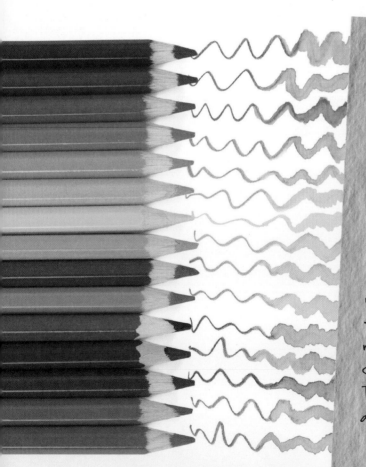

Consider Lightfastness

All color, regardless of whether in the form of colored pencils, watercolor, gouache, or pastel, starts with pigment. The pigment can be organic, which means it's found naturally, or it can be synthetic, which means it is manmade. Pigments can be sensitive to light and will fade, alter, or even completely disappear when exposed to too much indoor light or sunlight. Every manufacturer has a lightfast rating for each color. I recommend not using any color that doesn't have a "Very Good" or "Excellent" rating. For this reason, I suggest purchasing color supplies individually, rather than in sets. Try to purchase artist- or professional-grade art supplies, rather than student grade.

Watercolors

Watercolor is known for its transparent characteristics. Like watercolor pencils, there are many manufacturers, and it's best to buy the colors separately, rather than in sets. Watercolor paints are available in individual tubes or pans. I prefer to work with tube paints, as they are already fluid and easier to work with. If you're not sure where to start with watercolors, I recommend you explore these brands: Daniel Smith®, Winsor & Newton™, DaVinci™, and Holbein®.

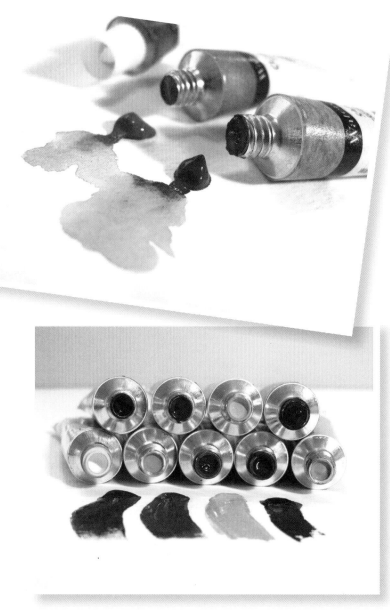

Gouache

Gouache ("gwash"—rhymes with squash!) is very similar to watercolor. The pigments tend to be more saturated than watercolor, making them less transparent and more opaque. You can add white gouache to any watercolor to make it opaque and less vibrant. Gouache can also be watered down to make it more transparent. The inherent quality of a pigment will determine how transparent or opaque the color will be.

Pastels

Pastels are typically in stick form, similar to chalk, and are usually applied with your fingers. Pastels have a higher pigment concentration than any other medium, and they can be either hard or soft. Soft pastels contain more pigment and less binder, so they are easier to smudge and are brighter. Hard pastels contain less pigment and more binder than soft pastels. It's a good idea to wear a mask when working with pastels, as the pigment dust can go airborne and be inhaled. You can also find pastels in pans.

Brushes

When I first started studying botanical and natural science illustration, I received a recommendation to work with Kolinsky pure sable brushes. These brushes are made from the fur of a specific type of weasel and come in a variety of shapes and sizes. They are relatively expensive. Personally, I didn't like these brushes; I prefer my brushes, no matter the size or shape, to have a flexible but stiff bristle. I prefer to work with synthetic brushes. Not only are they much less expensive, but also they afford better control. I love to draw, and I feel the most in "control" with this type of brush.

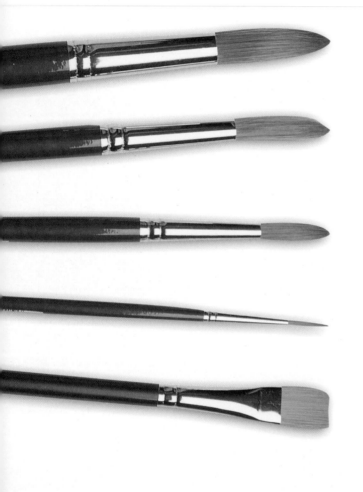

Watercolor Rounds When starting with watercolor and gouache, I recommend using a variety of round brushes. As the numbers on the brush get larger, the size of the brush increases. When covering a big area, I usually use a #10 or #12 round brush. For details, I work with a "spotter" brush, which is shorter and fatter and comes to a fine point. I usually work with a #0 or #2.

Chisel Brush A chisel brush looks very much like a square flat brush when looking at the brush head-on. When viewed from the side, the brush is wider at the base or "ferrule" of the brush, and tapers at the edge. This type of brush is great for cleaning up edges or lifting small lines when painting feathers or leaf veins. I prefer a #4.

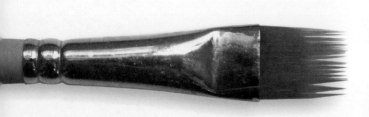

Rake or Comb Brush This brush is often used in decorative or folk art painting. It has the appearance of a flat brush, but half of the bristles are longer than the other half. The result looks like a comb or rake. This brush is perfect for creating textures like fur and feathers. I work with a ¼"- or ½"-wide brush.

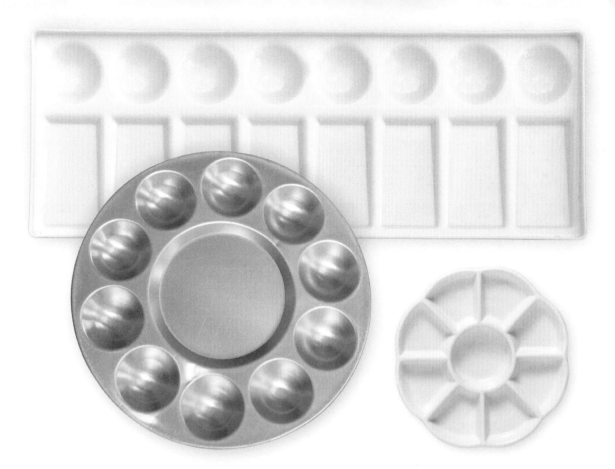

Watercolor Palettes

If working with tube paints, you'll need a palette to place your watercolor or gouache paints in. A palette can be as simple as a disposable plastic plate, a white china dish, or one of many options available in art & craft stores. I prefer to work with white porcelain palettes with six to twelve wells to give me areas in which to mix colors. I almost never completely clean my palette; this would be pouring money down the drain. Simply add a few drops of water to your dried paints to reconstitute them. White porcelain doesn't stain and accurately shows you the colors when mixing. Keep gouache and watercolor in separate palettes.

Studio Lighting

Working in a room with natural light is the best way to work. To add more light, I recommend a lamp specially formulated to replicate natural daylight. There are desktop models, standing lamps, battery-operated lights, and lamps with magnifiers built in. OttLite® is a reputable brand in the United States that can be found in art & craft stores and online retailers, as well as fabric stores.

Helping Hands

This little tool can be a great asset in the studio for holding flower tubes, as well as branches for drawing. It has several clips that can hold the tubes or branches, which can pivot to different angles. This allows for natural positioning, and all hands-free, for easier drawing. The base is weighted for balance to keep plants from falling over.

Sketching on the Go

Having a sketchbook with you all the time is a great idea. Some artists create amazing sketchbooks, with each page artfully done. For me, this kind of "sketching" is an art form unto itself and can take just as much time as a "finished" work of art. You can certainly work this way if you like. I believe sketchbooks can be used at five- to ten-minute intervals on the go. Keeping a small sketching kit with you can help you record bits of information and keep the momentum of your passion for nature going.

Sketchbook Paper size and type is a personal choice. I prefer something that easily fits into my backpack or purse. I currently work with a Moleskine® watercolor sketchbook (5" × 8¼"), because I like the overall surface to be lightly textured. This paper also prevents ink or watercolor from bleeding to the other side. The pages lay flat, and the cover is sturdy, providing stability when sketching and protecting drawings from bending or folding.

Pencil & Eraser I like to work with a mechanical pencil because it doesn't require sharpening. I also carry a "click" eraser for correcting drawing errors.

Ink If you want to work in ink, I suggest a marker with waterproof ink. There are many manufacturers that offer waterproof pens with different tip sizes. Waterproof ink allows you to apply watercolor on top of the ink drawing without the black lines bleeding or smearing.

Palette & Brush If you want to work in color, you can use a small travel watercolor kit. They can be expensive but are compact with mixing wells. You can also make your own by using a small pill dispenser and putting paints into the wells. A convenient, portable watercolor brush is great to have on hand. Load water into the barrel, and it's ready to go. Simply squeeze the barrel of the brush to release water into the bristles and into the paint in your palette.

Try to keep the supplies at a minimum, so they are easier to carry. You may also want to have a separate bag for your supplies so they don't get lost at the bottom of your backpack or purse. Just pull the bag out and go!

Cameras

Working from photographs has its challenges. One of the key considerations when working from photos is how much of your subject is in focus. Trying to understand and work from photos with soft or out-of-focus details can be frustrating. The term "depth of field" refers to how much of the subject is in focus. Greater depth of field means that more of the subject is in focus as the image recedes back. Price is always a consideration when considering a new camera. It's up to you to decide what you will be using your camera for and how much you want to spend.

Smartphone Cameras With today's technology, digital cameras are now standard on smartphones. I have an iPhone® that takes excellent photographs, as long as I'm not too far from my subject. I can easily capture flowers, plants, and close-ups with my phone. It's not useful for photographing birds, however. The zoom feature isn't good enough. As technology progresses, these types of features are improving. Smartphones may not take the best photographs all the time, but most people have them handy all the time, and your phone allows you to capture a moment without carrying too much equipment.

Digital Cameras There are two basic categories of digital cameras: point-and-shoot and digital single-lens reflex (DSLR). Point-and-shoot digital cameras, for the most part, are less expensive, more compact, and easier to use than DSLRs. Look for a point-and-shoot camera that has a high zoom capability, offers options to take photos with manual settings, and shoots photos at 12 megapixels or higher.

A DSLR camera consists of a main body that accepts interchangeable lenses. For instance, you can have a macro lens for close-ups, a telephoto lens for long-distance shots, and a wide-angle lens for panoramic views. These cameras are heavier, more expensive, and more complicated to use. They usually provide higher-quality image output.

Video Cameras

A camera with video capability is a great tool when you are out in the field observing birds. Video captures behaviors that cannot be captured by single images. Most digital cameras have a video function.

iPad® & Tablets

I fell in love with the iPad when it first hit the market. It completely changed the way I worked. When I first started a photo reference library, I used physical images cut out of magazines. Today, I use the iPad as a filing system for my digital pictures. Not only is this less expensive than printing all my photos, it takes up less space and I can easily zoom in on details. With the combination of Pinterest® and my own photo library, I have access to my reference images from anywhere.

Drawing Techniques

Learning to draw requires patience and dedication. Many people believe it's about talent, but drawing is a skill. With practice, it can be enjoyed by anyone who wants to learn.

Creating Tonal Values

One of the essential components of drawing is learning to create a range of tonal values. It's important to train the eye to see different shades of gray. I like to work with one pencil for most of my graphite drawings. Here are some beginning exercises to help you decide what strength of pencil you prefer. I do these exercises each time I purchase a new pencil from a new manufacturer. It helps me evaluate what I do and don't like about the pencil. On page 20 is a practice worksheet I use to evaluate each pencil and hone my skills.

Create three 1" × 1" boxes side by side, and label them 0%, 50%, and 100%. Using your pencil of choice, fill in the 50% or the 100% square first with even, smooth coverage. Start by using the side of the pencil, not the point, and move diagonally in elliptical shapes from one corner of the square to the other. To ensure that you're using the side of the pencil, your hand should be near the end of the pencil shaft to help the pencil lie flat on the paper. Don't worry if the strokes go outside the lines.

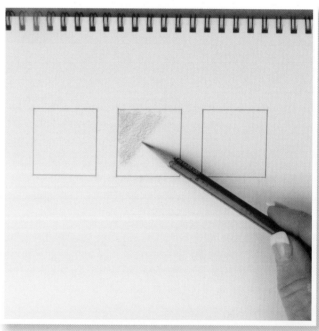

For the next layer, start at a different corner and work in the opposite direction, cancelling out the direction of the first layer. Then make a layer going straight across, and another layer going up and down. Changing the direction each time you create a layer eliminates texture or inconsistencies in tone.

When you can no longer deposit any graphite onto the paper with the side of the pencil, it's time to use the point. Before making the box darker, clean up any strokes outside the box using an eraser shield. Place the shield over the square and use a plastic eraser to erase any strokes outside the box.

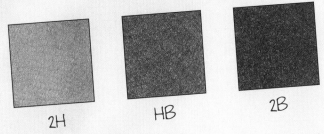

2H HB 2B

Saturation means that the tonal value cannot go any darker and has reached the maximum, or darkest, value. Saturation is different for different artists. Some people are heavy-handed, and some have a light touch. Be sure not to indent the paper or produce a high-metallic shine. The decision to cover the entire tooth of the paper is up to you. Each pencil produces different depth. A 2H pencil at full saturation will never be as dark as the full saturation of a 6B.

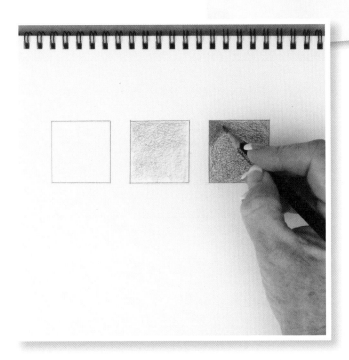

Sharpen your pencil to get a good clean point. Using the point, work in the same manner, changing directions with each layer. Shift the position of your hand so that it is closer to the point of the pencil. Continue to apply layer after layer until you have reached saturation.

For the 50% square, don't saturate the box completely, but approximately half the amount of the 100% square. Leave the 0% box blank. Squinting helps train the eye to see different values. You should see a white, medium gray, and almost black box when you squint at the three boxes. If the middle box is too dark, use a kneaded eraser to lift some of the graphite. Make sure that the eraser is soft and pliable, and flatten it so that it's larger than the square and completely smooth. Place the eraser over the square and press evenly to lift off graphite. Repeat if necessary. If the eraser lifts too much graphite, simply add another layer.

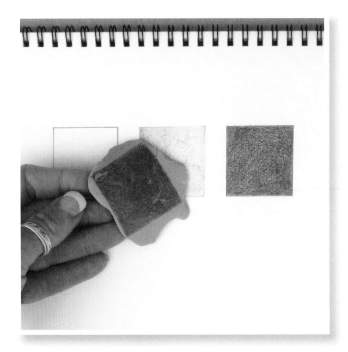

Graphite Pencil Worksheet

0%	50%	100%

0% 10% 20% 30% 40% 50% 60% 70% 80% 90% 100%

Incremental Smooth Tonal Scale

0% 10% 20% 30% 40% 50% 60% 70% 80% 90% 100%

Continuous Tonal Scale

Incremental Textured Tonal Scale

0% 10% 20% 30% 40% 50% 60% 70% 80% 90% 100%

Pencil Brand & Hardness:
Comments:

Tonal Scales

11-Step Tonal Scale This exercise is a continuation of the exercise on pages 18 and 19. The procedure is the same, but now there are 11 tonal increments, which increase by 10 percent saturation for each box. Use the printed tonal scale created by the computer (see below) to see the individual increments of tone, ranging from 0% to 100%. Remember: the computer uses ink and you are using graphite, so the color will vary.

Once you have mastered these basic skills, you'll have a good understanding of how to start a drawing and apply different values to a subject. These exercises can be repeated using watercolor, gouache, and colored pencils.

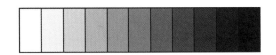

Try this exercise three different ways.

1. For the first scale, start with the 100% box and work from dark to light. Fill the 100% box, and then proceed to the 90% box, 80%, 70%, etc.
2. For the second scale, start at the 10% box and work from light to dark. Fill the 10% box, and then proceed to the 20% box, 30%, 40%, etc.
3. For the third scale, start at the 100% box, followed by the 50% box, and then find the percentages in between until you have completed the scale.

More than likely, you'll discover that one method is easier for you. Make notes as you work, and record how you felt doing each process. Regardless of which method works best for you, you'll find that you may need to go back and lighten or darken a box where tones are too similar. Remember to squint to identify distinct tones and determine where adjustments are needed. Be patient and remember that the more you do this, the better you will get. Don't spend hours trying to perfect one tonal scale. It's better to complete many scales than to try to get the first one perfect.

Continuous Tonal Scale In drawing you won't work in a paint-by-number fashion, with boxes of tone in increments of 10%. There should be a continuous flow of values. To create a continuous tonal scale, start by using the side of the pencil; but rather than staying in a confined square, the pencil will travel across the entire scale. Apply more pressure and more layers in the dark area and less pressure and fewer layers as the scale lightens in value. Change the direction of the strokes to produce smooth, even tone. Think of the movement as sweeping a broom across the paper. Try working light to dark, dark to light, and bouncing around to discover what works best for you.

11-Step Textured Tonal Scale In this exercise, focus on using the point of the pencil, rather than the side. To create interesting drawings, you must simulate different textures. For instance, you wouldn't try to draw every single leaf on a tree. By creating a textural pattern, you create the essence of what leaves looks like. The area where light directly hits an object is the highlight; the texture in this area is usually bleached out, and detail is minimal or missing. Where there is little or no light, the detail is lost in shadow. Areas in a medium amount of light have the most detail and texture. Use the point of your pencil and work light to dark, dark to light, or randomly. Darker tones should contain more layers and denser pattern.

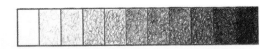

Color

For me, color has always been exciting. I am a color junkie! I love it and have never been afraid of working in it. I started out by purchasing every color that appealed to me, regardless of the medium. It was like being a kid in a candy store. I wanted it all. As I have learned through years of teaching, working in color doesn't come easily to everyone. And buying everything that's available does not make you a better colorist. Understanding how color works is what makes a difference.

Limited Palette

The easiest and most economical way to begin working with color is to start with a limited palette. I recommend, for instance, limiting yourself to six to twelve colors, regardless of what medium you work in. The primary colors—red, yellow and blue—cannot be mixed from other colors, but they can be used to theoretically mix every other color. Start to dissect, identify, and classify color by asking the following questions:

- Is the color clear, bright, and vibrant?
- Does it fall somewhere in the midrange?
- Does it appear muddy, neutral, or muted?

In this example, I have digitally created six bright, clear, vibrant colors: two yellows, two reds, and two blues. As you can see, not all "primary" colors are the same. They are affected by the basic properties of the core pigment. I like to start with colors that are the brightest, because I can always mute or tone them down. You can't, however, make a color brighter by adding anything to it. Yellows are either green-yellows or orange-yellows. Reds are either orange-reds or violet-reds. Blues are either green-blues or violet-blues.

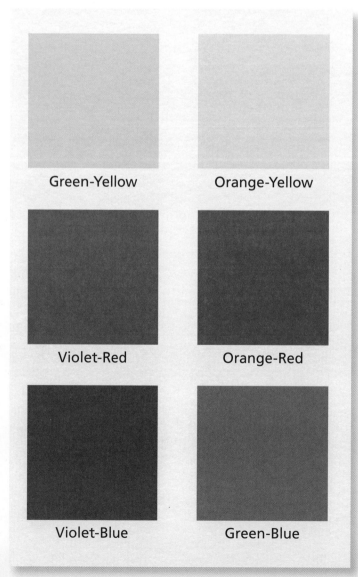

Green-Yellow Orange-Yellow

Violet-Red Orange-Red

Violet-Blue Green-Blue

Testing Colors & Making Color Charts

Every time I purchase a new color, I test it to identify its clarity or neutrality, as well as what else might be in the color. I created templates for myself on the computer, and then I print the template on either watercolor or drawing paper and do a series of tests, depending on the medium. Below is an example of my template, and what it looks like in action. You can create something similar, or come up with your own version.

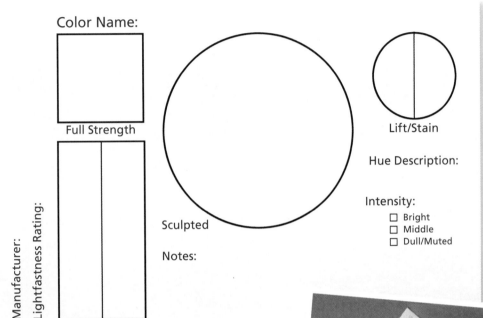

Color Name:

Full Strength

Manufacturer:
Lightfastness Rating:

Sculpted

Notes:

Graduated Wash

Lift/Stain

Hue Description:

Intensity:
- ☐ Bright
- ☐ Middle
- ☐ Dull/Muted

Adding More Colors

I think it's essential to start with two yellows, two reds, and two blues. The number and variety of colors that can be mixed from this limited palette is amazing. Here are some other colors you might consider adding to your collection:

Yellow Ochre This organic, muted yellow tends to be on the slightly orange side. It's one of the oldest natural pigments found in prehistoric cave paintings.

Burnt Sienna This natural, organic pigment is orangey-brown. It tends to be transparent and strong. I use it in conjunction with blues to create deep, rich browns and blacks.

White Use white to lighten colors, as well as make colors opaque.

When printing templates, keep in mind that 300-lb. paper will likely not feed through the machine. I normally print templates on 140-lb. paper. You should also ensure that the ink is waterproof. If it isn't, any moisture applied to the paper will make the ink run and intermingle with the colors. If you don't have access to this process you can create your own swatches by using a template cutout and a permanent waterproof marker.

Neutral Grays There are many varieties of grey. Some are more brown or orange, and some are more blue. I prefer a neutral gray on the blue side. This color is sometimes called Payne's gray or neutral tint. When purchasing a color, look at the manufacturer's chart to see what it says about the color so you have a visual idea before purchasing it.

Granulating Paints Granulating watercolors can add dramatic effects to a painting with very little effort. The trick is to use them with lots of water and lots of paint. This landscape was done using only one color, Moonglow by Daniel Smith.

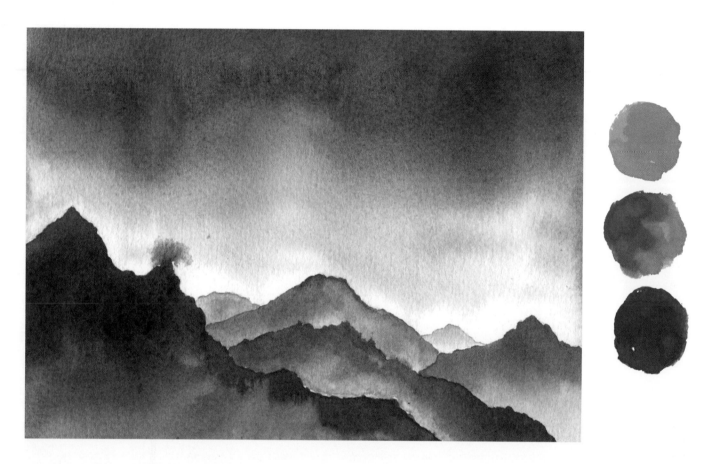

Favorite Colors I find it impossible to not have my favorite color, purple, in my box of colors. I know how to mix various shades of purple, but I can't resist having it on its own as well. If you have a favorite color or colors, it is always a great addition to your palette!

Pick and choose your colors wisely. Go for the best and brightest colors you can afford. Look for artist- or professional-grade colors that are lightfast. Avoid buying sets unless you get a super sale, as many colors will never be used. Select reputable manufacturers that sell individual colors to cut down the cost when replenishing supplies.

The actual color name may be the same from manufacturer to manufacturer, but that doesn't mean it is made from the same pigments. For instance, in testing different colors named lemon yellow from different manufacturers I found that some were green-yellows and some were orange-yellows. Don't trust the name the manufacturer has given the color. Look at the descriptions and color swatches.

Color Mixing

Color Saturation

Each color has a saturation level. This means that it reaches a level of coverage and depth on the paper without being mixed with anything else, similar to working monochromatically in graphite—each pencil has a different saturation level. A 9H pencil saturates to a pale grey, while a 9B pencil saturates to almost black.

Yellow has the lightest value and saturates quickly. The tonal range for yellow is 0% to 30%. Extending the range of yellow requires the addition of another color. In this example, a neutral was added to both yellows. The end of the scale for each yellow results in a mixture that is no longer yellow. Violet-blue has a much darker value and broader tonal range. When a neutral is added to extend the range, the color is altered but still a violet-blue.

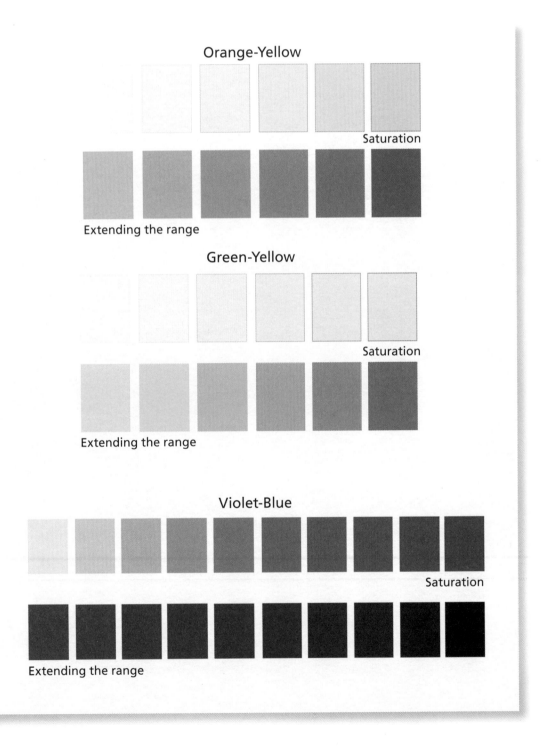

25

Mixing Greens

Nature artists routinely go for every green paint, pencil, or pastel imaginable. You can mix easily mix a huge variety of greens using the two yellows and two blues in your limited palette. Generally, if you want a bright, clear green, combine green-blue with green-yellow. Adding violet-blue into the mix adds a bit of red. When any combination of red, yellow, and blue are put together, the colors begin to go muddy, darker, and neutral.

Creating Recipes

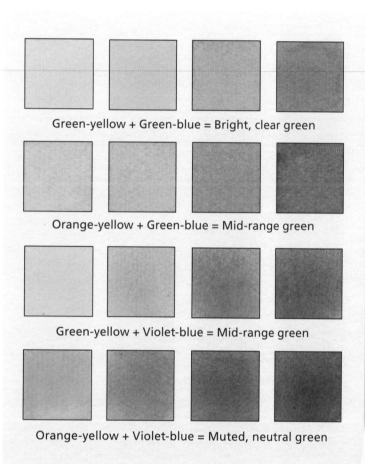

Green-yellow + Green-blue = Bright, clear green

Orange-yellow + Green-blue = Mid-range green

Green-yellow + Violet-blue = Mid-range green

Orange-yellow + Violet-blue = Muted, neutral green

For this kind of exercise, I created another type of template. I mixed all the colors on the palette, starting with the yellows and slowly adding the blues. I wet the paper first and then added paint, starting with the darkest value and adding water to dilute the paint for the lighter values.

I do this kind of color mixing for all projects, whether in watercolor, watercolor pencils, colored pencils, gouache, or pastels. Keeping a color mixing journal will add to your swatch library and help build confidence. For my journal, I use loose ring binders and keep my swatches on the ring. Like a chef or baker refers to the recipe box, when I'm working on a new illustration I can pull any card and look at my notes to recreate the color. I encourage you to create your own system, and add to it as you increase your color inventory.

When using yellow to mix greens or other colors, use yellow first. Yellow saturates easily and quickly becomes something else. To mix greens, start with yellow and add small increments of blue. It takes a lot less blue to create variations of green. If you start with blue, you can end up using the whole tube of yellow before you reach your desired color.

Brush Techniques

The key to working in watercolor or gouache is to know how much water to paint is needed for the desired effect. Shown at right are some swatches I created using a neutral tint.

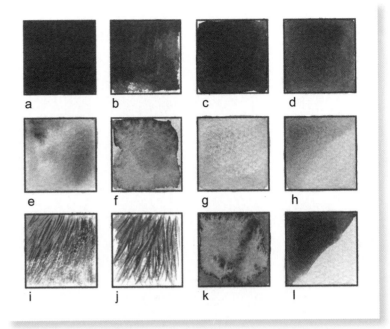

a. Solid Coverage: Thick paint applied on dry paper. This shows a heavy concentration of paint, which completely covers the paper.

b. Uneven Coverage: I moistened the paper unevenly with water first, and then applied paint. The coverage is uneven.

c. Even Coverage: I evenly moistened the entire area first. I used thinned, but not watery, paint and dropped it into the square. The paint disperses evenly.

d. Even Coverage: I pre-moistened the paper evenly. I used a thinner paint consistency, which results in even coverage with a lighter value.

e. Uneven Paint/Even Coverage: I pre-moistened the paper and dropped in different strengths of paint using the tip of the brush.

f. Bloom: A bloom occurs when the moisture level of the paint is greater than the moisture level of the paper. The paint moves to the edges of the wet area and dries darker.

g. Light Values: Applying more water to the paint creates lighter values. This sample shows the first layer of paint applied very thin on moistened paper.

h. Graduating Layers: First I paint a light value swatch and let dry. Then I apply a second application over the dry swatch at the top left corner. The new layer graduates into the value of the first layer. Note that the entire area must be moistened or a line will form. (See swatch i.)

i. Drybrush: Using the tip of the brush, I add linear strokes on dry paper with either "wet" or "dry" paint. The drier the paint, the less defined the strokes will be. The wetter the paint, the thinner the lines will be.

j. Combination of Lifting & Drybrush: I apply linear paint strokes to the paper, and then use a chisel brush to lift linear paint strokes to create dark and light lines adjacent to one another.

k. Second-Layer Bloom: I apply the first layer evenly and let dry. I moisten the paper, and then add paint for the second layer. The moisture level on the paper is less than the moisture level of the paint, allowing the paint to move across the paper and create uneven texture.

l. Layers with Delineation: I apply the first layer evenly and let dry. I apply the second layer to dry paper only on the top left, diagonally. The result is a clear line. If the paper had been wet, a soft line would have appeared, as in swatch h.

These techniques can be used with any water-based medium: watercolor, gouache, or ink. Experiment to understand the ratio of water to paint to achieve the desired consistency and look. The best thing to do is experiment on small test sheets, like this example, and make lots of notes. This type of practice gives you control and confidence.

Photographing Botanical Subjects

When photographing botanical subjects for illustration, it's important to get as much information as possible. Too often, photographs are taken from far away with lots of distracting elements. This series of photos shows you how to take a better reference photo.

Here is a shrub in my yard. It's wild senna, or *Cassia hebecarpa*. It's a tightly clustered shrub with lots of beautiful yellow flowers. I placed my drawing pad under a cluster of flowers to take the picture. You can see there are other elements in the photo. The white pad blocks out the ground and other plants so that I can more clearly see the flowers. If you have someone to help you, try using a larger piece of paper behind the subject. Have your assistant hold the paper, which allows you to better crop and focus on your subject before taking the photo.

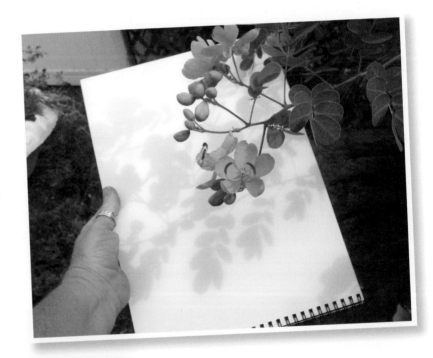

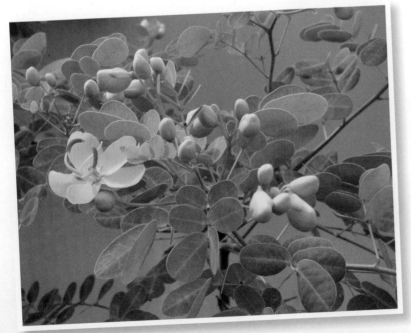

Behind the shrub is a concrete wall. I shifted the position of my camera to eliminate the distractions in the background. The composition is complex, and there is too much going on, but it does capture an accurate depiction of how the shrub grows. Because of the camera and lens I used, some of details in the photo are out of focus.

In this photograph, I used a light meter to take a sample of a smaller cluster of flowers. The depth of field is relatively shallow, with the background landscape in shadow. This created a dark background and isolated the plant.

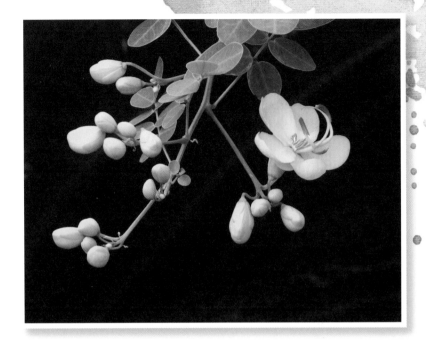

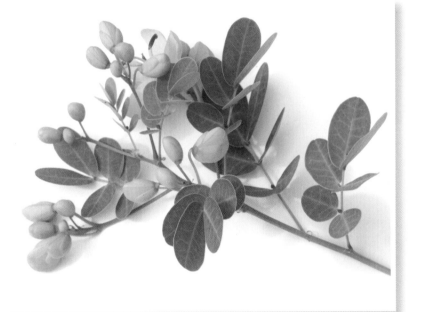

Finally, I pruned off a branch and brought it inside, placed it on a large sheet of white paper, and used my OttLite to illuminate it. This photo eliminates all distractions. It's clean, neat, and easy to understand. You have many options in photographing botanical subjects. It's not always possible to cut the plant to bring inside. The most important aspect is to eliminate distractions by moving the camera around the subject or placing something behind it to block other elements.

A light meter measures the amount of available light to determine the proper exposure for a photograph. This handy tool tells you how to set the shutter speed and f-stop on your camera for optimum exposure.

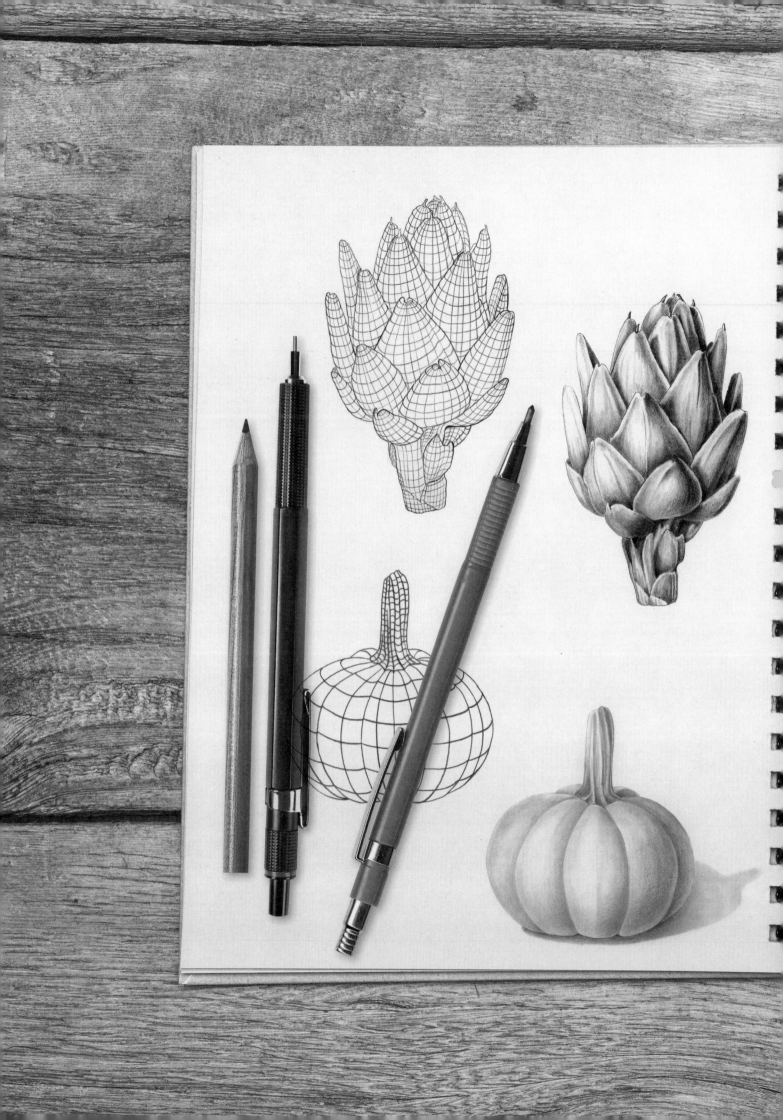

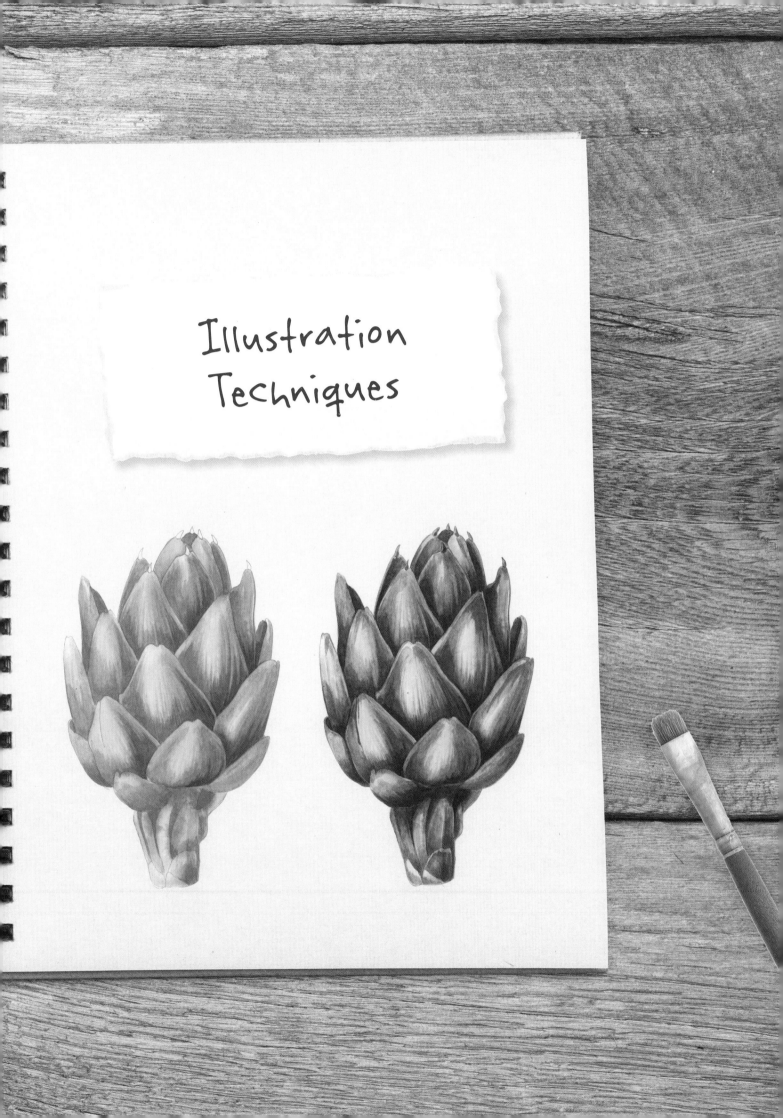

Illustration Techniques

Accurate Drawing

What makes a drawing come to life? A drawing comes to life when it is accurately rendered to depict proper perspective. This includes understanding the viewpoint and angle of the subject, creating volume by following the surface contour, applying light to the object to create gradations of tonal value, and studying surface texture, color, and details.

Perspective

Perspective, as it pertains to drawing, means recording a three-dimensional object on a two-dimensional surface to render a realistic appearance of the object in life by accurately representing all aspects of the object through proper perspective and skill. To make the translation from reality to paper, it's vital to learn the rules of perspective. We'll start with the picture plane, which is an imaginary, flat, transparent plane held parallel to the artist's angle of vision and the subject. The subject can be seen at, below, or above eye level. Shown below is a box at, below, and above the artist's eye level.

The Picture Plane

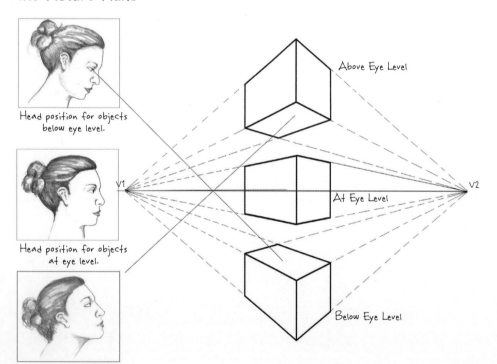

Head position for objects below eye level.

Head position for objects at eye level.

Head position for objects above eye level.

Above Eye Level

At Eye Level

Below Eye Level

V1

V2

Note that the head is tilted to correspond with the viewpoint. Any shift or change results in a "different" picture. While drawing and measuring, it's essential to stay within a fixed viewpoint.

You can use an 8" x 10" piece of clear plexiglass as a temporary physical picture plane to help with measuring and foreshortening. The plexiglass helps "flatten" the picture plane, much like a camera does when creating a photo. Note that if movement occurs during the measuring or drawing process, it changes the viewpoint(s) and renders the drawing inaccurate.

Simple Forms

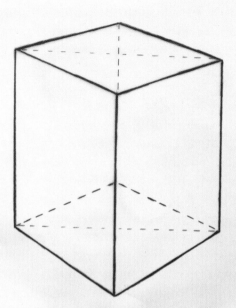

It's easy to see how the basic geometric forms originate from a box.

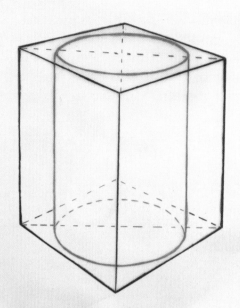

The cylinder has a flat bottom and top. The four walls of the cube round to form the cylinder.

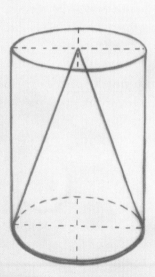

The cone has a flat bottom, but the sides are no longer parallel to one another. They converge at the top.

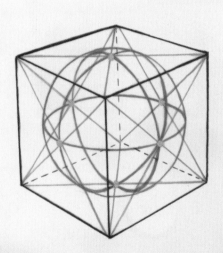

On a perfect cube, all six sides are the same size. The sphere touches each plane of the cube in the center, indicated by the green dots. There is no longer a flat surface, as the surface contour has changed dramatically.

Surface Contour

Think of surface contour as a topographical map of an object. To clearly see the surface contour, it helps to create an *armature* drawing. An armature drawing shows how the different planes move, curve, and shift. Look at the basic forms below. Each can be broken down into specific planes or surfaces, and the shape of each surface changes as lines transform from straight to curved.

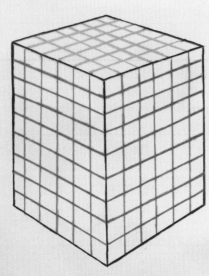

In a box, all the surface contour lines are straight. The blue lines depict the vertical terrain, and the pink lines depict the horizontal terrain. The top of the cube is also flat, with straight green lines.

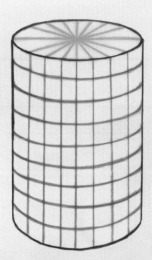

In a cylinder, the blue vertical lines remain straight. To depict the "roundness" of the cylinder, the pink horizontal lines are now ellipses. The top of the cylinder has changed from a rectangle to a circle. The top is still flat, and the lines are divided into slices radiating from the center axis, rather than a grid.

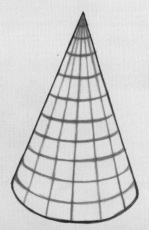

In a cone, the pink horizontal lines remain ellipses. The blue vertical lines stay straight, but because the top of the cone is pointed, all the vertical lines converge to the top. The flat top and green lines disappear.

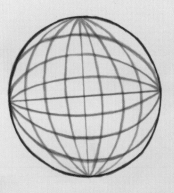

In a sphere, there are no straight lines. All the lines are ellipses. The blue lines depict the vertical terrain, and the pink lines depict the horizontal terrain.

Lighting a Subject

Once you understand the surface contour of an object, apply light to create form and bring it to life. Botanical and scientific illustration requires a consistent light source for uniformity. On any given day or time of day, the light can change. When you're working indoors, setting up a consistent light source allows for optimization of form.

If possible, use a light that recreates natural sunlight. I recommend using an OttLite, because its soft, natural light creates diffused cast shadows.

Setting the Light for Optimum Results

Below is a comparison of two different lighting setups. The photographs have been converted to grayscale so that it is easier to see the comparison.

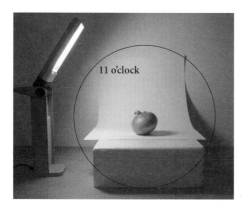

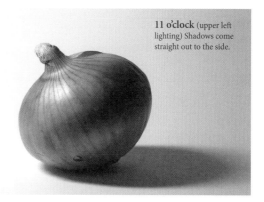

11 o'clock (upper left lighting) Shadows come straight out to the side.

11:00 Lighting Light is directed from the left at 11 o'clock, with the light raking from the left side and down. Take a closer look at the onion, and notice that the highlight is found at the upper left. The right side is much darker than the left, with details missing in the darker areas. The shadow is elongated and dominant.

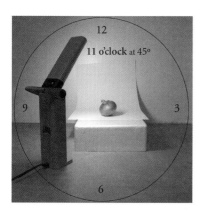

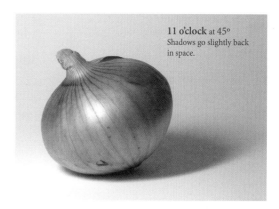

11 o'clock at 45° Shadows go slightly back in space.

11:00-at-45-Degrees Lighting Here, the light remains at 11 o'clock but is shifted 45 degrees from the picture plane. Notice the subtle differences. The highlight is still in the upper left of the onion. The left side is lighter than the right, but more details are visible on the right side in the darker areas. The shadow is smaller and recedes in space.

The second lighting setup gives the best form and detail to work from. I highly recommended setting up your subjects like this to create the best scenario. Over time it becomes possible to imagine this kind of lighting in your mind's eye and you can apply it to any subject, whether you are working with a studio setup, ambient light, outdoors, or negating the light source in a photograph. The goal is to always be consistent.

Simple Forms with Light Source

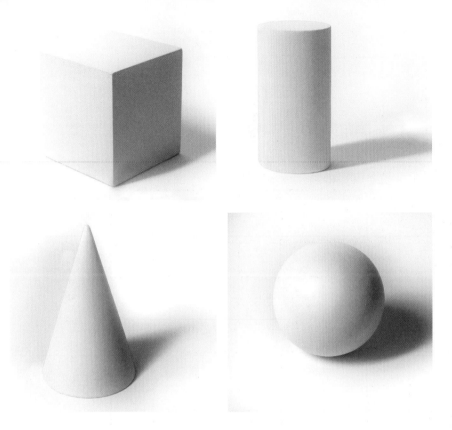

The photographs here show how light hits these plaster forms using the 11:00-at-45-degrees angle.

As you have seen, the surface contour is different for each subject. Notice how the light source shows the difference in the shapes of the highlights, middle, and shadow areas, as well as the shapes of the reflected highlights and cast shadows.

Cast Shadows

In botanical and scientific illustration, the subject typically floats in space. Depicting your subject on a surface results in a cast shadow, which eliminates the appearance of floating. Cast shadows also appear when one subject is in front of another—for instance, one leaf in front of another leaf. The leaf in the foreground casts a shadow onto the leaf in the background.

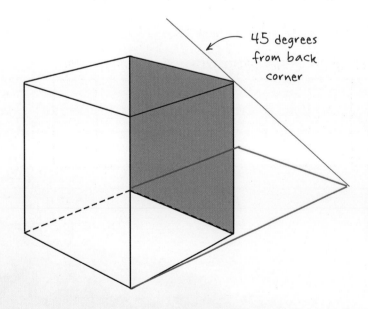

45 degrees from back corner

In this diagram, notice that the gray back side of the cube casts the shadow onto the surface. The length of the shadow is determined by the height of the cube and the 45-degree angle from the left back corner.

When one object is placed in front of another, the shape of the cast shadow conforms to the shape onto which it is cast.

The cone in the front is casting a shadow onto the flat plane of the cube. Since the plane is flat, the cast shadow does not vary from the shape of the cone.

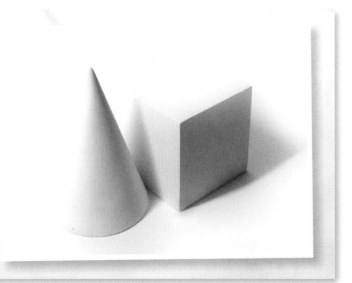

When the cone is placed in front of the sphere, the cast shadow conforms to the shape of the sphere's surface contour, which is round.

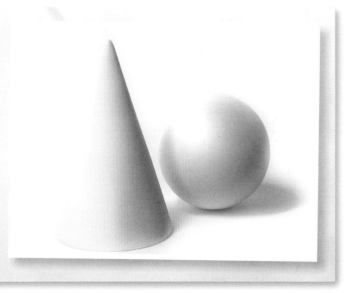

When a cylinder that is much taller than the cube is placed in front, the cast shadow folds over the flat surface of the cube's top.

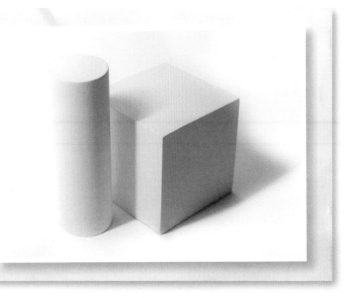

How Surface Contour & the Light Source Work Together

This series of graphite drawings depicts three pumpkins and the subtle differences in their overall shape and surface contour.

This pumpkin is spherical, or egg shaped. It is smooth all the way around. I applied graphite in the direction of the surface contour.

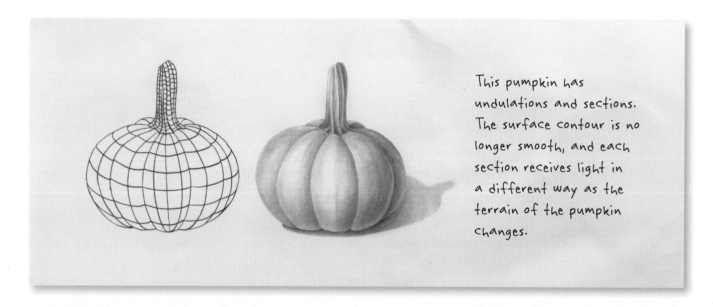

This pumpkin has undulations and sections. The surface contour is no longer smooth, and each section receives light in a different way as the terrain of the pumpkin changes.

This pumpkin is more compressed, and the sections are more defined. Each section bulges out in the center and tapers toward the stem and bottom. Each section has a highlight, but as the sections move away from the light source, the highlights and shadow areas darken.

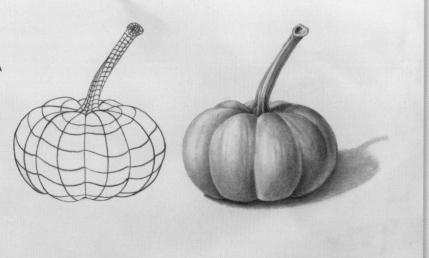

How Light Affects Color

Working in graphite helps us learn how to understand and properly render light, form, and texture. Working in graphite is considered *monochromatic*, or one color—that color is gray.

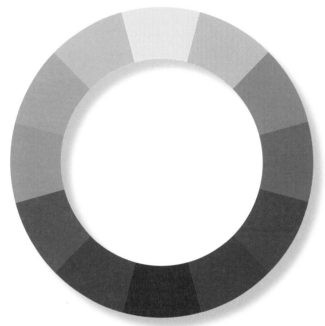

Every color has its own value range, as demonstrated in the color and value wheels here. For example, yellow has a very narrow range and blue has a broader range. The key to extending the range of a color without changing it into a different color is through accurate, interesting color mixing.

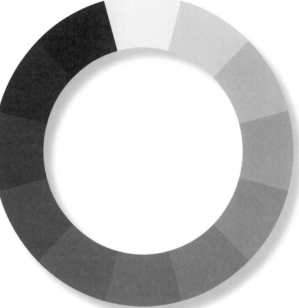

Local Color

Local color is a description that generally states the basic color of an object. The apple is red. The flower is yellow. The sky is blue. These are examples of local color. An artist needs to represent both form and true color representation simultaneously. There are many options to consider.

It's important to develop your own style of color mixing. Try the exercise on the following page, and make notes as to what works best for you. The results may surprise you!

The six spheres below are rendered in colored pencil. The local, or main, color is true blue (PC903) by Prismacolor. True blue is a medium-range blue that contains some green, rather than purple.

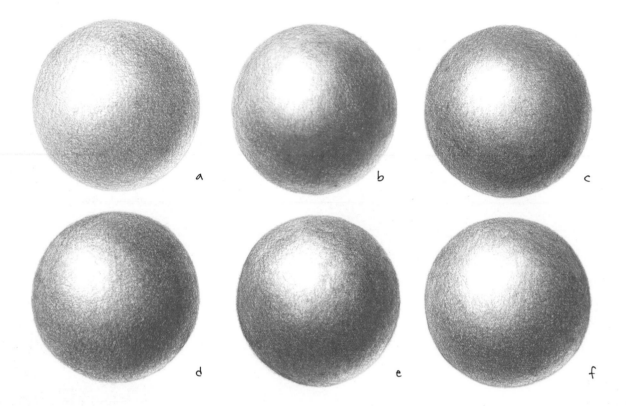

Here is a breakdown of the different approaches to extending the range of color, while still maintaining the local color.

a **Monochromatic** This method uses only one pencil. In this example, I used true blue (PC903) to apply color in gradations of tone following the surface contour. This method is identical to working in graphite.

b **Monochromatic with a Colorless Blender Overlay** This method is identical to the monochromatic method, but is finished with a top layer of colorless blending pencil over the entire sphere. Notice that the color is much more vibrant. The blender eliminates the texture of the paper and intensifies the color.

c **Analogous** This method uses different colors of blue, all within the same green-blue category. Instead of varying the layers and the pressure, I used lighter shades of green-blues. I used true blue overall to maintain the local color, peacock blue (PC1027) in the middle and shadow areas, and indigo blue (PC901) in the deepest shadow areas.

d **Undertonal Painting** This method uses a darker neutral color to create form in a monochromatic application. Once the form is rendered, apply the local color on top of the undertonal drawing. In this example I used light umber (PC941) for the undertonal drawing, with true blue on top.

e **Complementary** This method uses colors that are opposite one another on the color wheel. When mixed together, complementary colors can also turn "muddy," so this method can be challenging. Here I used true blue and cadmium red hue (PC124), an orange-red. Apply the colors in alternating layers, and use cadmium red very lightly to avoid muddying the local color.

f **Triad** This method uses colors that create a triangle on the color wheel. In this example, I used three colors: canary yellow (PC116), pomegranate (PC195), and true blue. Canary yellow is an orange-yellow, and pomegranate is a red-purple. Use all three colors in alternating layers. True blue remains the dominant local color, but now different amounts of unusual color can be seen through the layers.

Complicated Surface Contour

When the terrain of a subject is more complicated, it's important to understand that the light source must follow both the overall shape of the subject as well as the smaller shapes within the subject. Below are a couple of examples.

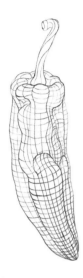 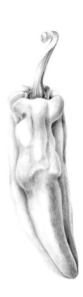 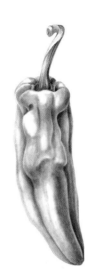 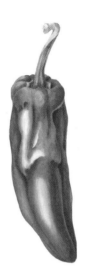

This red pepper is basically a cylinder shape with odd twists and turns. The surface texture is shiny and smooth. Shown here is a breakdown of the armature drawing, tonal drawing, and final watercolor painting.

This artichoke is basically a globe sitting on a cylinder. While the overall highlight is at the upper left, the surface texture plays a huge role in how light hits the overall shape. Look at the surface contour of each section. Each leaf casts a shadow onto the one behind it. As the overall form turns away from the light, it gets darker.

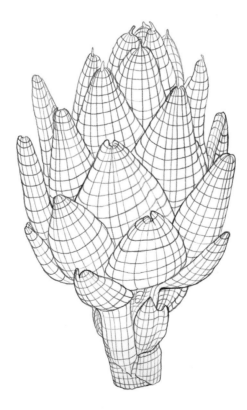 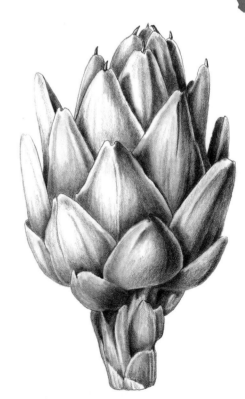

This step-by-step demonstration breaks down how to render the artichoke in watercolor. The color scheme is analogous, with accent colors added for details.

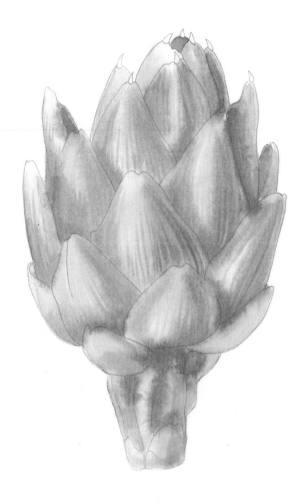

Apply a generous layer of water to the entire surface, including the stem. Using the tonal drawing on page 41 as a guide for the light source, add the shadow areas. Be sure to preserve the highlights. Work the entire area while it's wet.

Allow the paint to dry, and then apply a darker mixture of green paint to strengthen the shadow areas, using a semi-dry brush technique (see page 27).

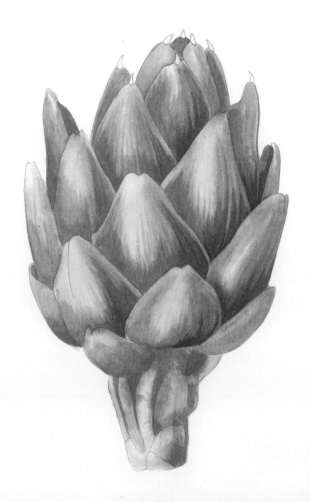

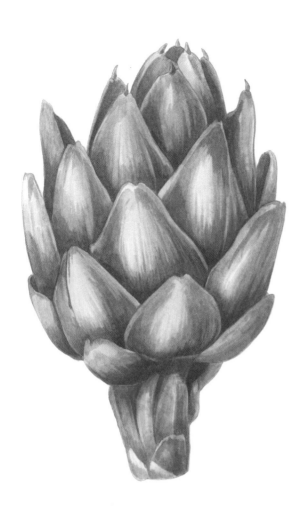

Strengthen the form by using the dry-brush technique to introduce subtle color variations, such as purples and browns, to add interest and character.

Finish the color, form, and details with a smaller detail brush.

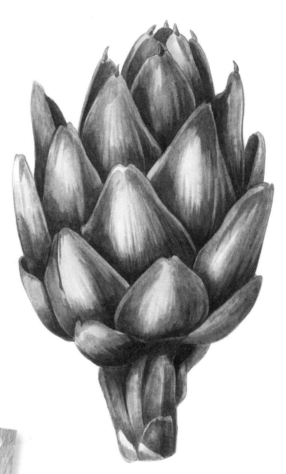

To create the basic green color mix, I used hansa yellow light, phthalo blue, and ultramarine blue.

Leaf Identification

To say that leaves come in many shapes and sizes would be an understatement!
The variety is endless. For a species to be properly identified, it's highly important
to render your drawing accurately. The tiniest detail could mean the difference
between one species and another. Isn't that amazing?

Here are some questions to ask about the characteristics when identifying
and drawing leaves.

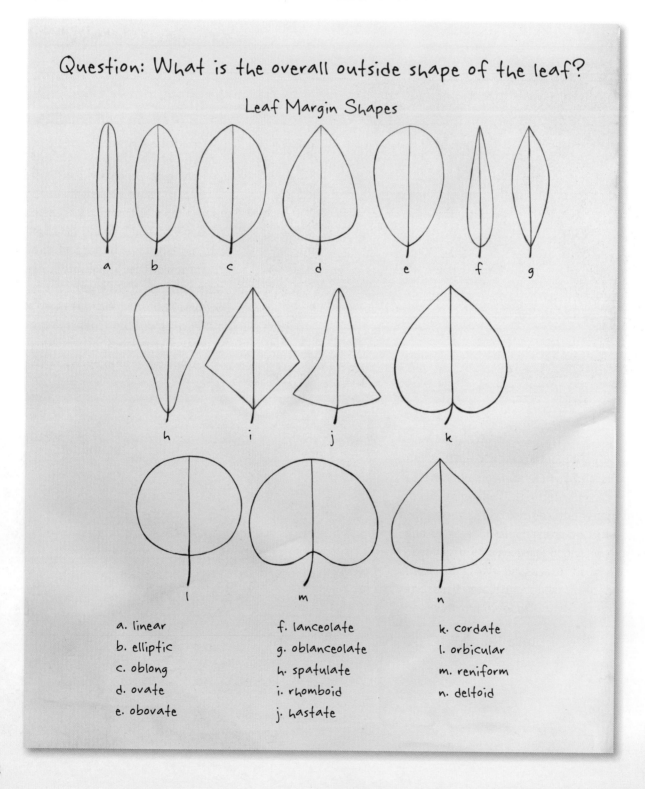

Question: What is the overall outside shape of the leaf?

Leaf Margin Shapes

a. linear
b. elliptic
c. oblong
d. ovate
e. obovate

f. lanceolate
g. oblanceolate
h. spatulate
i. rhomboid
j. hastate

k. cordate
l. orbicular
m. reniform
n. deltoid

Question: What does the tip of the leaf look like?

Leaf Tip Shapes

a. obtuse
b. retuse
c. emarginate
d. truncate
e. acuminate
f. cuspidate
g. acute
h. apiculate
i. aristate

Question: What does the base of the leaf look like?

Leaf Base Shapes

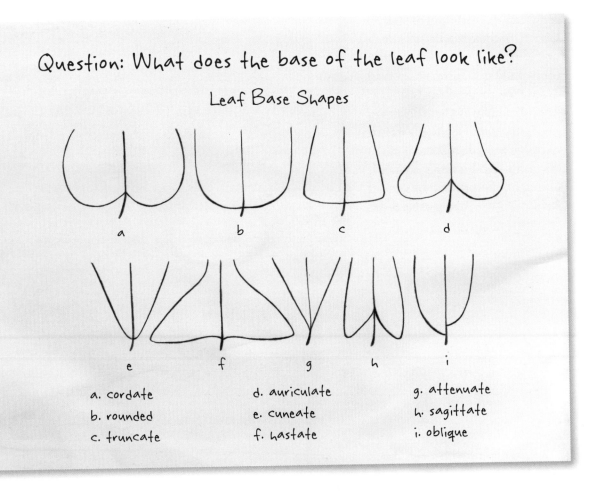

a. cordate
b. rounded
c. truncate
d. auriculate
e. cuneate
f. hastate
g. attenuate
h. sagittate
i. oblique

Question: What does the edge of the leaf look like?

Leaf Margins

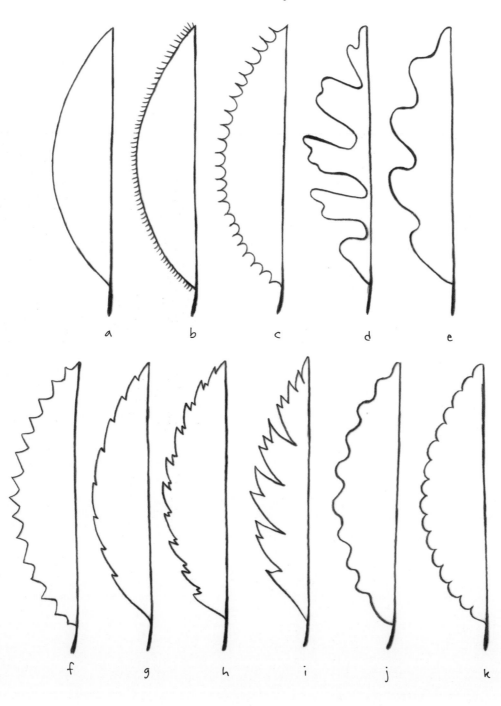

a. entire

b. ciliate

c. pectinate

d. cleft

e. lobed

f. dentate

g. serrated

h. doubly serrated

i. incised

j. sinuate

k. crenate

Question: How are the veins arranged on the leaf?

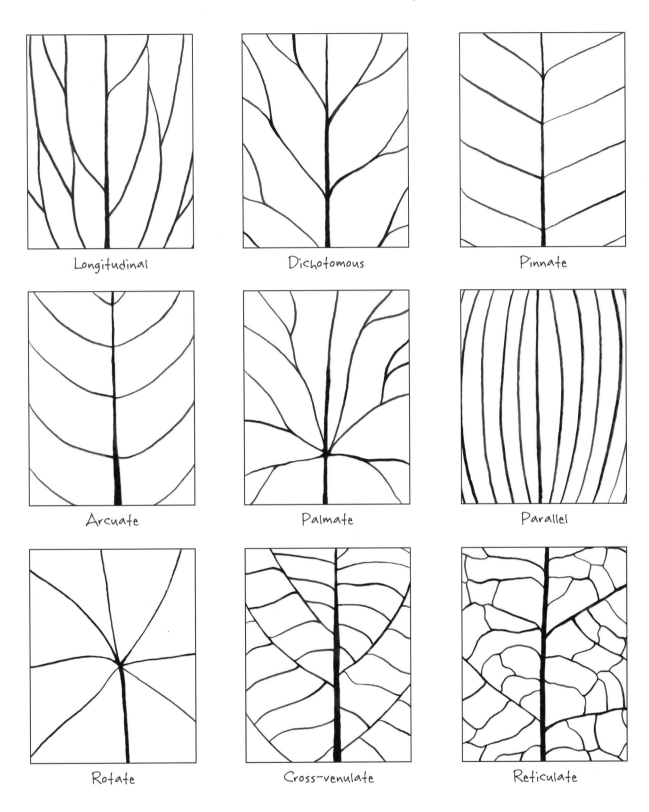

Longitudinal

Dichotomous

Pinnate

Arcuate

Palmate

Parallel

Rotate

Cross-venulate

Reticulate

Common Leaf Venations

It's important to begin by observing these characteristics, as they are deciding factors in knowing what specie of plant you're drawing. Keeping a leaf sketchbook will help you to begin to learn these characteristics. (See pages 136-137 for tips on creating a sketchbook.) Below is an example of how I keep a leaf sketchbook.

Passion vine
Passiflora incarnata

Railrod vine
Ipomoea pes-caprae

Crossvine
Bignonia capreolata

Oakleaf Hydrangea
Hydrangea quercifolia

Red Buckeye
Aesculus pavia

Firebush
Hamelia patens

Beach Morning Glory
Ipomea imperati

Write down any characteristics you feel are unique to the plant. Visit the library or Internet and research the plant to learn more about it. If you know its Latin name, you will find accurate information. Most plants also have a common name, but it may or may not translate to the same specie from one region to another. The Latin name gives you accurate information regardless of where you found the plant or what the regional common name is. Even if you don't know the plant's common or Latin name, it's still important to observe and accurately record the information.

Leaf Anatomy

To portray plants accurately, it's important to understand simple leaf anatomy. The stem is the part of the leaf that attaches to the branch. It usually flows into the midrib, which tapers to the end of the leaf where it usually—but not always—ends in a point. A series of veins branch off from the midrib. These are the primary veins. The primary veins branch off into secondary veins and, in some cases, the secondary veins branch off into capillaries.

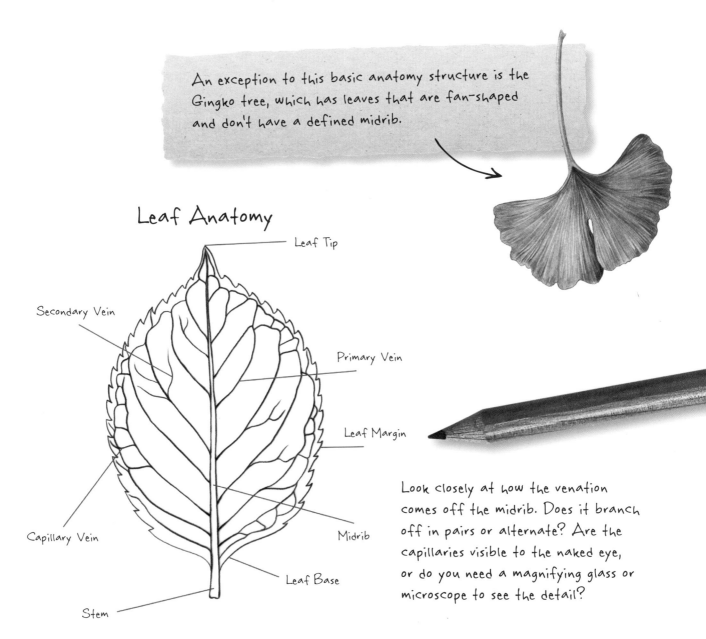

An exception to this basic anatomy structure is the Gingko tree, which has leaves that are fan-shaped and don't have a defined midrib.

Leaf Anatomy

- Leaf Tip
- Secondary Vein
- Primary Vein
- Leaf Margin
- Capillary Vein
- Midrib
- Leaf Base
- Stem

Look closely at how the venation comes off the midrib. Does it branch off in pairs or alternate? Are the capillaries visible to the naked eye, or do you need a magnifying glass or microscope to see the detail?

How Much Detail?

This is a question you should routinely ask yourself in the preliminary stages of planning an illustration. There are many ways to answer this question, and I always respond with, "It depends!" The number one question you want to ask yourself is this: Who is this drawing for? A botanist, a Girl Scouts troop, a botanical art competition?

Follow the tips below to help you decide how much detail to add to your botanical illustrations.

- If you're creating work for a botanist, he or she usually wants to highlight a specific feature. It's important to know exactly what the focus of the illustration should be from the start. Find out how much detail is required to avoid either having to start over or spending too much time developing unnecessary detail.
- Know your target audience. If the illustration is for a certain age group, make sure you depict enough information for this audience. For instance, if the illustration is for a Girl Scout's field guide, it shouldn't have too much detail, but it should be recognizable and suitable for learning basic plant identification.
- If you're creating a piece for a botanical art competition, find out who the jurors are. See what others before you have done, and work toward that standard.
- If you are doing it for yourself, enjoy, observe, and see what works for you—explore the possibilities!

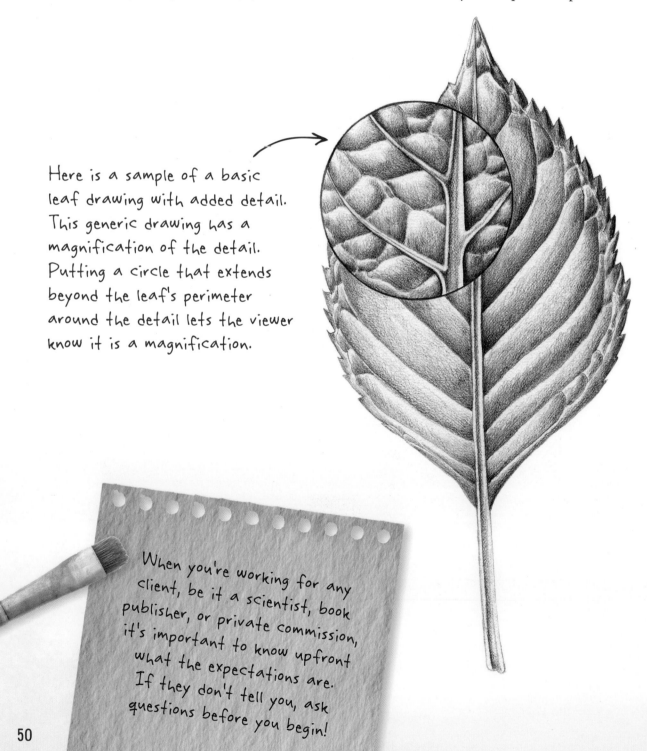

Here is a sample of a basic leaf drawing with added detail. This generic drawing has a magnification of the detail. Putting a circle that extends beyond the leaf's perimeter around the detail lets the viewer know it is a magnification.

When you're working for any client, be it a scientist, book publisher, or private commission, it's important to know upfront what the expectations are. If they don't tell you, ask questions before you begin!

Leaf Rubbings

The underside of a leaf typically has raised veins. An easy way to record the venation is to create a rubbing, which gives you a visual record of the venation long after the leaf has died. The rubbing process damages leaves, so collect more than one of the same type for additional reference while you work.

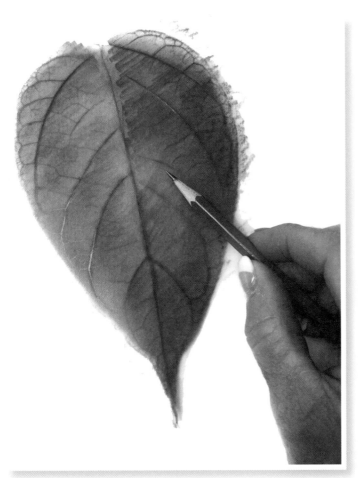

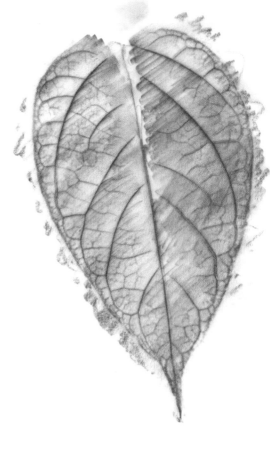

Place the leaf topside down on a table or flat surface, with the underside facing up and the raised veins exposed. Then place a piece of tracing or vellum paper on top. Make sure the paper is tight and smooth by holding it down with your non-drawing hand or using removable artist tape. Just don't put any tape on the leaf!

Use the side of a soft lead 2B pencil to apply graphite over the entire leaf. The veins will appear on the tracing paper. Make sure to include the leaf margin. Once you have finished the rubbing, remove the tracing paper and discard the leaf.

Drawing a Leaf Front & Back

Use leaf rubbings as a starting point for drawing a leaf front and back. Follow these directions, and give it a try!

Refined Drawing

Place another piece of tracing paper over the rubbing and trace a more refined drawing, using the rubbing to determine how the veins come off the midrib. This is the stage where you decide how much or how little information will go into your drawing. Make sure all the veins connect to the midrib. Then transfer the refined drawing onto a clean sheet of drawing paper.

Light Source: Front of Leaf

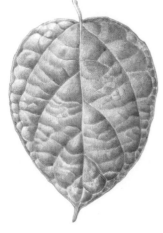

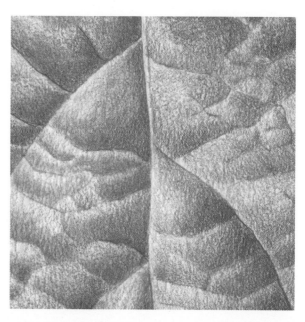

This is of the top, or front, of the leaf, which has a slightly puckered surface. Using the light source of 11 o'clock at 45 degrees gives it greater depth and form and accentuates the convex shape. Tape your leaf to a wall and photograph it with the light source as reference.

Each section of the leaf on both sides appears as a convex, half-spherical shape. This is achieved by following the surface contour of each undulation. The tonal values incorporate the venation and get lighter where the leaf protrudes and is closer to the light source.

The midrib and all the veins that end at the leaf margin should always taper, starting out thicker at the point of origin and becoming thinner as they approach the margin. If the leaf margin is serrated, the veins taper and end in the center of the point of the serration. All veins must be attached, without any gaps.

Light Source: Back of Leaf

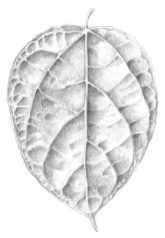

The back of the leaf is a reverse image of the front. The veins protrude and each section is concave, going inward. The light source is still in the same position, but the result is the opposite, due to the change in direction of the surface contour. Notice how the highlights are now in reverse, and each raised vein casts a shadow to its right onto the leaf.

Impressed Lines

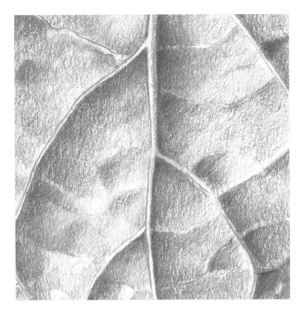

It can be difficult to create tiny white veins. A simple and effective way to render fine lines in a drawing is to *impress* them into the paper. To do this, start with your tracing paper drawing, so you already have the top of the leaf drawn. You will use it again to create the underside of the leaf.

Indicate which side of the tracing paper is the top of the leaf by writing the word "top" in the corner to prevent confusion. Flip the tracing paper over and carefully trace only the outline of the leaf. You want the leaf margin to transfer onto the paper but not the veins, which will be white.

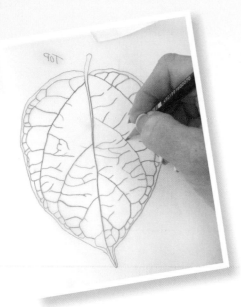

Keeping the paper with the word "top" facing down, slide it off the drawing onto a scrap piece of paper. Trace the veins. The graphite on the veins will transfer onto the scrap paper, and the venation lines will be on both sides of the tracing paper.

Flip the tracing paper over so the "top" side is facing up, and erase the venation lines. Be careful to remove all the graphite from the interior of the leaf.

Flip the tracing paper over again, and realign the leaf margin you just transferred. If necessary, use a small amount of removable tape to keep the tracing paper in place. Using a 2H or hard lead pencil, transfer the venation lines, carefully and firmly going over the lines. You may want to practice on a scrap piece of paper first to see how much pressure is needed.

When you remove the tracing paper, you should see only the outline of the leaf. The venation, although invisible, is indented into the paper. Using the side of your drawing pencil, lay down graphite in the direction of the surface contour. The venation will appear as fine white lines. The line is impressed or "recessed" into the paper and will not accept graphite.

When impressing lines, it's important to place a magazine or several sheets of scrap paper between the drawing you are working on and the pad of paper. You will be pressing hard onto the paper, and you don't want the lines to appear in other drawings. You can also remove the paper from the pad to avoid this problem.

Twisting Leaves

There are so many sizes and shapes of leaves found in nature. Drawing accurately is always important, but the drawing must also flow to make it truly come alive on the page.

Plastic Leaf Model

This exercise helps accurately depict a leaf turning and twisting in space. Even better, these plastic models can be kept and reused time and again. The flexible wire allows for the leaf to be turned and twisted in different directions.

Materials
- Clear plastic sheet of acetate
- Black water-resistant marker
- Floral or other rigid but flexible wire
- Scissors
- Clear 2-inch packing tape

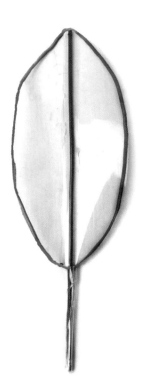

Cut a 6-inch piece of floral wire for the midrib. Tape the wire onto the acetate, ensuring that the wire is in the center of the tape. Draw an elliptical leaf shape in black marker, approximately 1" on both sides of the wire. Cut out the leaf.

Drawing a Twisted Leaf

Follow this easy, step-by-step demonstration to use your new plastic leaf to practice drawing twisted leaves.

Twist the leaf into position, as demonstrated here.

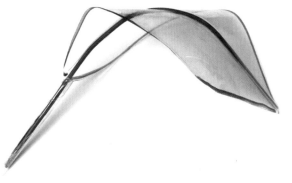

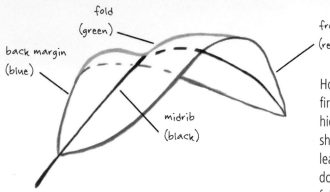

fold
(green)

back margin
(blue)

front margin
(red)

midrib
(black)

Hold the leaf in your non-drawing hand, and draw the midrib first, shown here in black. Use a dotted line to show the part hidden by the leaf. Draw the closest outer edge of the leaf, shown here in red. Then draw the furthest outer edge of the leaf, shown in blue. This line is partially obstructed (note the dotted portion), as it is hidden from view. Finish by drawing the fold of the leaf, shown in green.

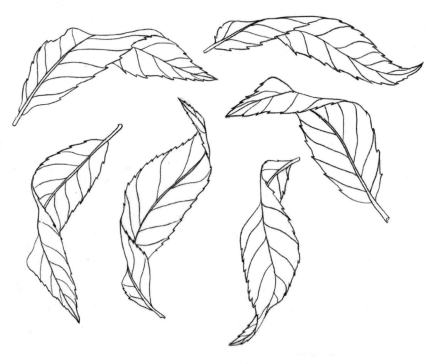

Place a piece of tracing paper over your drawing, and refine it to make the leaf come alive. Add serrated edges and veins. See how many ways you can twist and turn the leaf—this is a great drawing exercise!

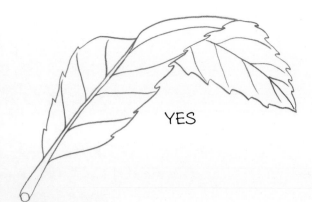

YES

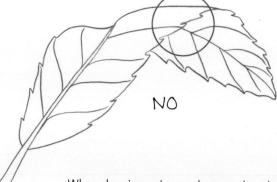

NO

When drawing veins, make sure that the veins from the underside do not intersect with the veins on the topside. This can ruin the perspective of the leaf. The veins should alternate.

Drawing a Branch

Once you're comfortable drawing leaves, move on to branches. Choose a branch that is manageable, and gradually work into more complex branches. Plants wilt easily, so it's a good idea to place the branch in water in a vase or flower tube and keep it in the fridge when you're not working to keep it fresh. Once the branch is in position, consider thinning out clusters of leaves that are hard to "read." I call this "artistic pruning." Just be careful not disturb the basic characteristics of the plant.

Remember to draw the midrib first. This is very important to the continuity of the drawing.

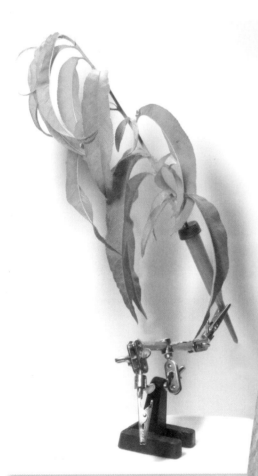

Set up the branch for drawing. I'm using a tool called a "helping hand" to hold the branch. Set up the light source and take photos. You should also create a rubbing of one of the leaves for reference.

First Observations

- If possible, identify the species or common name.
- If possible, collect more than one branch from the same species and compare. Do they all have the same characteristics or are there differences?
- Record how the leaves come off the branch: alternate, spiral, whirl, or in pairs?
- Measure the length and overall measurements of the branch. Does it fit on your paper?
- "Artistically prune" the branch by strategically removing some of the leaves. How many leaves are there? Can you change the number and still be true to the growth cycle of the plant?

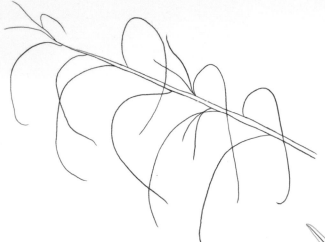

Working on tracing paper, draw a simple line drawing that shows how the branch angles and how the leaves grow from it. Measure the length of the branch and the space between each leaf stem. The result looks like a series of sticks.

Measure the distance between the leaf tips and angles. Starting with the farthest leaves, draw the largest elements of each leaf first. Draw continuous lines through the branch and any leaves. Then erase any lines that intersect or overlap. To keep track of where you are, mark an "X" in the negative space areas, an "F" for the front of a leaf, and a "B" for the back of the leaf.

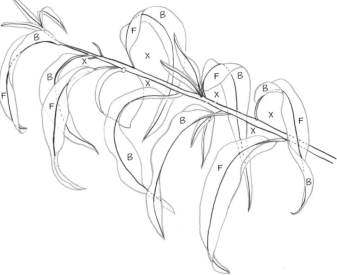

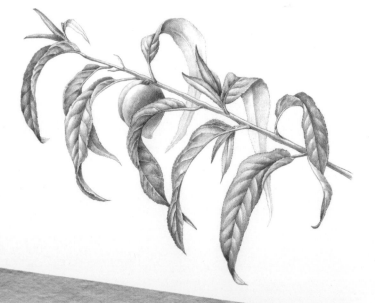

Use a clean sheet of tracing paper to refine your line drawing before transferring it onto drawing paper. Add fullness to the branch and more graceful curves to the leaves.
Working with multiple layers of tracing paper allows you to erase without losing your foundation drawing. You can alter the composition by changing the length—but remember to retain the basic characteristics of the plant. You can trace a leaf and reposition it in another part of the drawing. Be creative! The drawing should end up on one piece of tracing paper that you can transfer onto good drawing paper.

Treat your drawing like a story. Think of it this way: Letters become words. Words become sentences. Sentences become paragraphs. Paragraphs tell a story. Similarly, sketches become components. Components become elements. Elements are added to the composition. The composition tells the STORY of the plant! Through observation, drawing, redrawing, editing, and manipulation, you tell the branch's story and bring it to life on paper.

Atmospheric Perspective

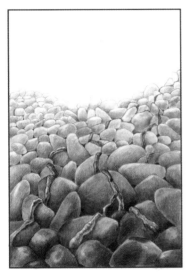

Atmospheric perspective works on the premise that objects in the foreground are darker and, as they recede from the viewer, become lighter. This technique and concept is very common in landscape artwork. Another principle of atmospheric perspective is that objects closer to the viewer have more detail. Detail always comes forward, regardless of whether it is light or dark.

Notice how the foreground rocks in this drawing have more detail and contrast and are larger. As they move toward the horizon line, the detail, contrast, and size diminish.

Artists use atmospheric perspective to achieve greater depth and realism in their artwork. In botanical illustration, leaves are often so close together that a drawing can look compressed. To create a more open feeling, use a natural progression of fading to achieve atmospheric perspective.

In this example, I faded all the leaves on the back of the branch. I toned the back leaves first, lifted some of the values with a kneaded eraser, and then toned the leaves in the foreground, adding more of the light source, contrast, and detail.

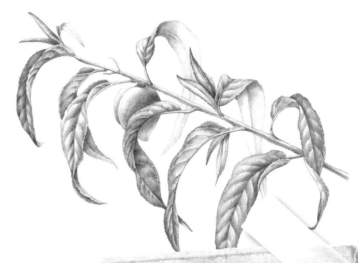

Tips for Creating Atmospheric Perspective

- First determine the focal point of the drawing. Is it new growth on the branch? Older leaves in the foreground? A vine that trails off? Does the plant have multiple branches?
- After answering the above questions, decide what features to emphasize, and what to put in the distance.
- Example: If the focus is new growth at the end of the plant, you should incorporate a lot of detail in this part of the drawing. As you progress down the branch, use less and less detail.
- Tip: If you want to fade the background leaves, I recommend toning them first and "fading" them by using a kneaded eraser to lift tone up.
- Remember that there are many possible ways to create "fade" in your artwork. Experiment within the same drawing to explore some of the options and see what you like best.

Root Systems

Botanical illustrations often include the root system of a plant. Botanical illustration was birthed as a means of recording plants for identification purposes. Historically, an expedition would travel to a foreign land with the express purpose of bringing back as many specimens of plants and animals as possible. Plants perish quickly, so they were drawn as quickly as possible. Many plants were too large to fit on a single piece of paper, so individual parts of the plant were drawn separately. The root system was just as important to a plant's identification as the rest of it!

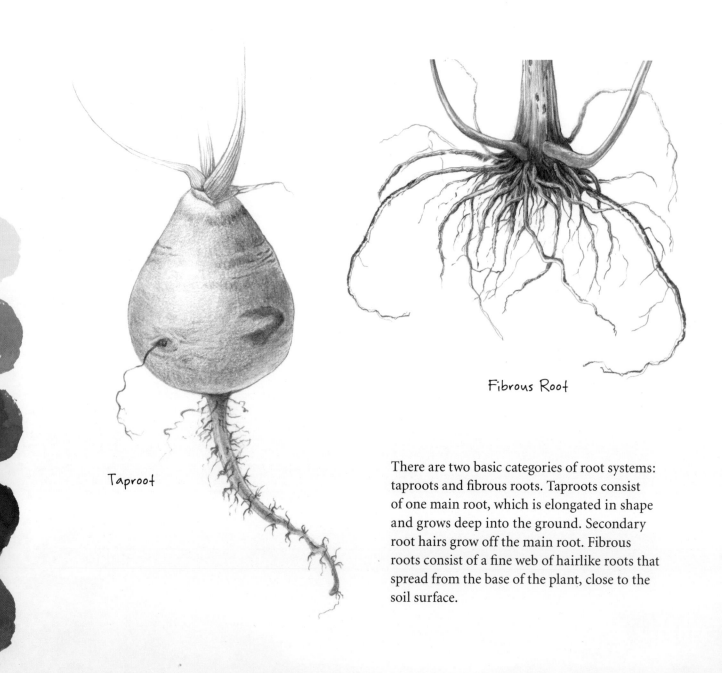

Fibrous Root

Taproot

There are two basic categories of root systems: taproots and fibrous roots. Taproots consist of one main root, which is elongated in shape and grows deep into the ground. Secondary root hairs grow off the main root. Fibrous roots consist of a fine web of hairlike roots that spread from the base of the plant, close to the soil surface.

Setting Up a Root System

The challenge for the illustrator is to make the roots look natural, as if they are still in the ground. Follow the steps below to set up a root system before drawing.

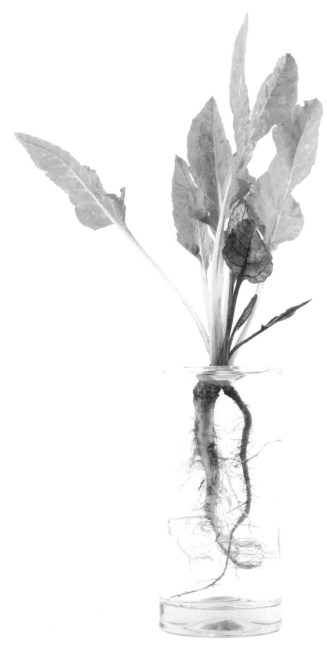

- Gently remove the plant from the ground by digging around it until the soil is loose enough to remove the plant. Roots can be fragile; to avoid breakage, don't pull too hard. If damage occurs, you can reconstruct the root system in the drawing.
- Clean the plant and remove as much dirt as possible. The roots will usually droop and sag, clinging to one another at this point.
- Prune back as much of the plant as you want.
- Place the plant and root system in a clear container of water that has enough room for the roots to spread easily. If it's too small, the roots will clump on the bottom or cling to the sides. You want them to be able to float and have as much room as possible so that they appear as they did underground.

At first glance, roots appear tangled and intimidating and too many to count! Don't try to count the number of roots—just like you wouldn't count the leaves on an entire tree or the strands of hair on a person's head. The key is to accurately assimilate what the root system looks like, not replicate every single root.

If you're drawing the entire plant, including the root system, it's important not to dig the plant up until the last minute. Often, a plant goes into shock and wilts when removed from the ground. Save the root system for last, as it will last longer.

Drawing a Root System

Since this drawing is about the root system, illustrate minimal information for the rest of the plant. Remember that detail always comes forward. If you render more detail on the roots, the emphasis will be on the root system. In this demonstration, we'll draw an amaryllis bulb.

Pick some of the foreground roots and draw them first. Fill in with additional roots, working from front to back. As the illustration evolves, some roots are hidden behind one another.

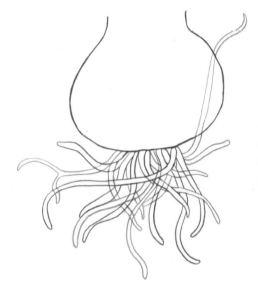

Draw as many roots as you wish until it looks realistic and full. If you're working on tracing paper, be sure not to clutter the drawing with too many roots, which will make it very difficult to transfer.

Transfer onto good drawing paper. After you have transferred the drawing, add tone to make it three-dimensional. I use both principles of toning at this point. I toned the roots in the foreground that are tightly spaced light to dark. You may find that some roots cast shadows onto the roots behind. As the roots become less dense and move further away from the bulb, I chose to fade them so there appears to be more space around them.

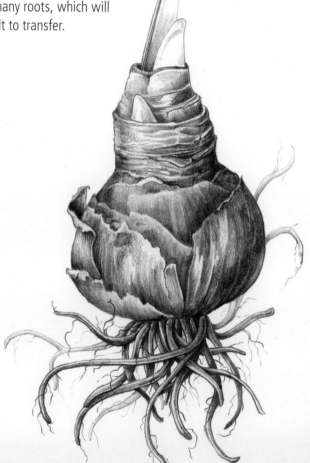

Adding Color with Gouache

To add color, I used a limited palette of gouache paints: burnt sienna, lemon yellow, and ultramarine blue.

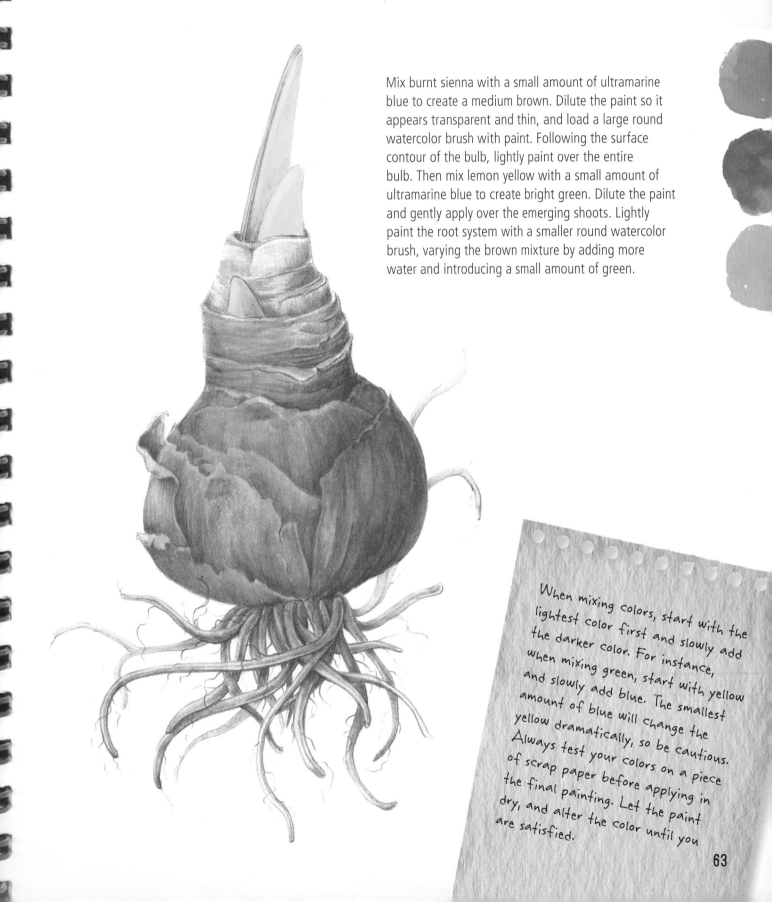

Mix burnt sienna with a small amount of ultramarine blue to create a medium brown. Dilute the paint so it appears transparent and thin, and load a large round watercolor brush with paint. Following the surface contour of the bulb, lightly paint over the entire bulb. Then mix lemon yellow with a small amount of ultramarine blue to create bright green. Dilute the paint and gently apply over the emerging shoots. Lightly paint the root system with a smaller round watercolor brush, varying the brown mixture by adding more water and introducing a small amount of green.

When mixing colors, start with the lightest color first and slowly add the darker color. For instance, when mixing green, start with yellow and slowly add blue. The smallest amount of blue will change the yellow dramatically, so be cautious. Always test your colors on a piece of scrap paper before applying in the final painting. Let the paint dry, and alter the color until you are satisfied.

63

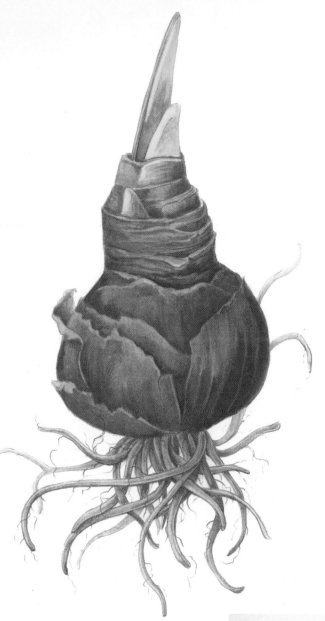

Let the paint dry completely. Create more of the brown and green mixtures with less water, and deepen the values by adding more ultramarine to each color. The paint mixtures should be thicker and less transparent. Begin to slowly layer paint in the darker areas to create more depth, following the surface contour. Layer color until you can barely see the graphite. Some artists stop painting at this point. The hint of graphite showing through gives the piece the appearance of an old tinted, black-and-white photograph.

Working again with the thicker paint, use a small round watercolor brush, such as a spotter, to cover up any remaining graphite. Use fine lines to sharpen the details. If the paint becomes too thick, you can gently apply a wash of clean water over an area to soften it.

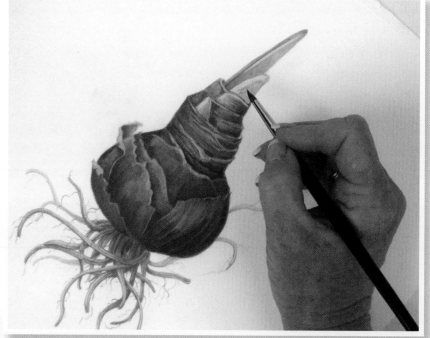

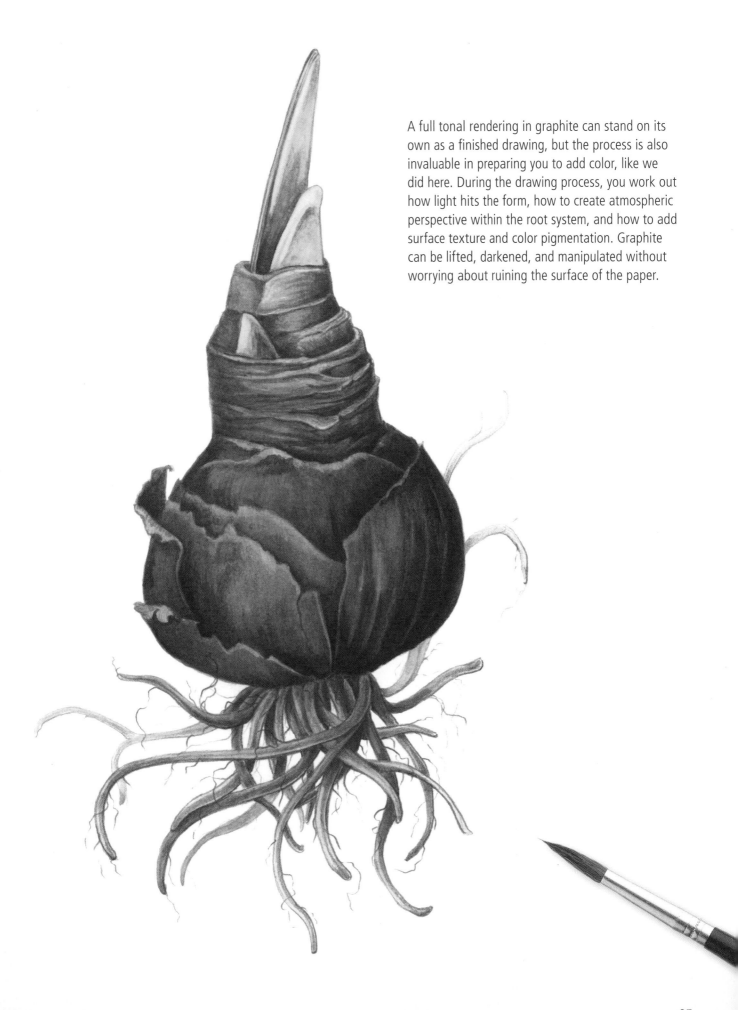

A full tonal rendering in graphite can stand on its own as a finished drawing, but the process is also invaluable in preparing you to add color, like we did here. During the drawing process, you work out how light hits the form, how to create atmospheric perspective within the root system, and how to add surface texture and color pigmentation. Graphite can be lifted, darkened, and manipulated without worrying about ruining the surface of the paper.

Flowers

Flowers are the showiest part of a botanical painting. They come in many shapes—and even more color variations than leaves. It's easiest to break down flowers into two categories: *monocotyledons* and *dicotyledons*.

Monocotyledons

Mono is Latin for "one." *Cotyledon* pertains to the part of the seed where the plant sprouts its leaves. All flowers in this category have parts in multiples of three. Leaves are usually long and narrow, with parallel venation. Common monocots are lilies, tulips, and orchids.

Dicotyledons

Di means two and, when combined with *cotyledon*, it means there are two parts of the seed that sprout leaves. All flowers in this category can have multiple flower parts ranging from four, five, or more. Dicot leaves have many different types of patterns, such as pinnate, venulate, or palmate. Geraniums, pansies, and roses are all examples of dicots.

Monocot

Dicot

Basic Flower Anatomy

A single flower starts at a stalk, the pedicel. The base of the pedicel is where all parts of the flower originate. This is called the receptacle, and the sepals, petals, stamens, and carpels all grow from it.

The sepals come first, followed by the petals, the stamens, and finally the carpels. If you examine a flower in its immature stage—as a bud—you can peel off each layer of the receptacle to reveal the underlying layers.

Together, sepals and petals are called the perianth. As a group, the petals are called the corolla. The stamens are the male reproductive parts of the flower and consist of a stalk (the filament) and an anther, which holds the pollen. The carpel is the female reproductive part and consists of one or more egg cells, which are enclosed within an ovary. The outside of the carpel consists of a style, and at the end of the style is the stigma. This is the general vocabulary of the various parts; the configuration or arrangement of these parts varies from species to species.

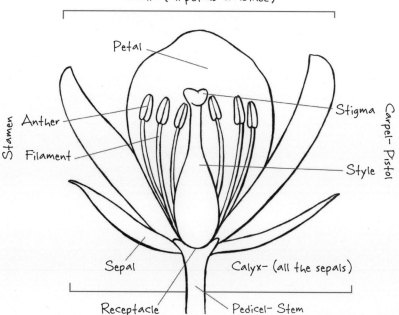

Anatomy of a Flower

Corolla (all petals combined)

Petal

Stamen — Anther

Filament

Stigma

Carpel-Pistol

Style

Sepal

Calyx- (all the sepals)

Receptacle

Pedicel- Stem

Some flowers have fused sepals and/or petals, such as daffodils. To prepare for drawing, collect several flowers of the same species. Use a craft knife to cut through the receptacle, starting at the pedicel, to see how the parts come together. I recommend starting out dissecting larger flowers. To avoid injury, always cut away from your body and not near other people.

Basic Flower Shapes

There are many shapes and sizes of flowers. The easiest way to understand them is to break them down into the basic shapes. Below is a sample of common flower shapes.

Common Flower Shapes

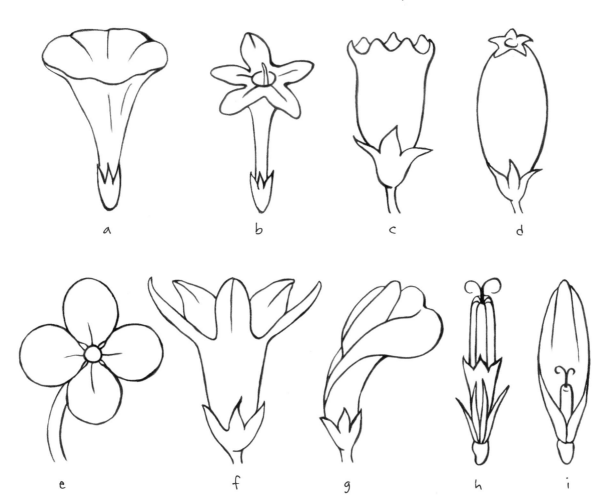

a. Funnelform – funnel
b. Salverform – tube
c. Campanulate – bell
d. Urceolate – urn
e. Cruciform – cross

f. Coroniform – crown
g. Alate – wing
h. Tubular – disc
i. Ligulate – ray

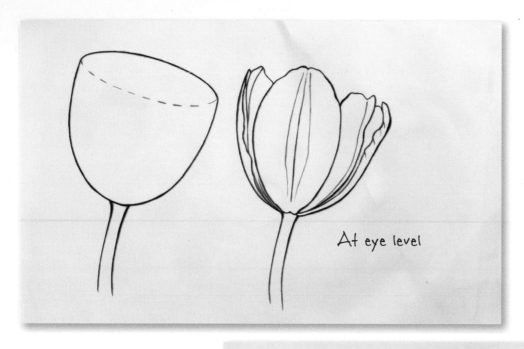

At eye level

Once you begin to see different flower shapes, it's important to keep in mind the angle or viewpoint from which you are looking. In this example, I've placed a tulip at three different viewpoints. The flower can be described as a basic teacup shape. As the viewpoint gets lower, the interior of the flower becomes more visible.

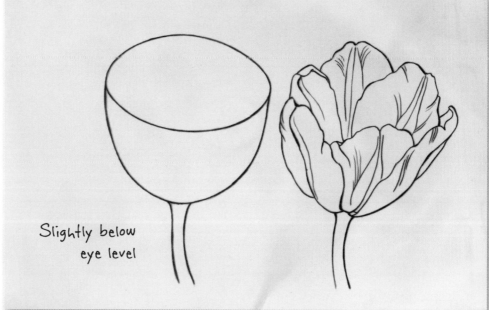

Slightly below eye level

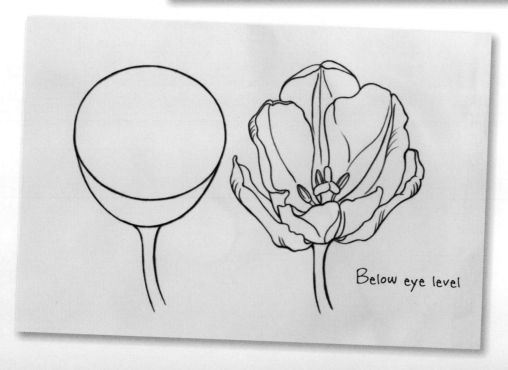

Below eye level

Flower Arrangements

Just as you have seen patterns of venation on a leaf and how leaves are arranged on a stem, flowers are arranged systematically on the plant. They can be arranged as a single flower at the end of a stalk, like a tulip, or they can be arranged in a cluster, like a lilac. *Inflorescence* is a general term that describes how flowers are grouped or arranged on a plant.

Sketchbook Assignment

Collect a series of flowers, and begin to enter them in your sketchbook. You can do this by a specific category or a random sampling. Here are some things to think about while drawing:

- Where is the flower located? Is it standing alone? Is it near the tip of the branch, by the stem, or both?
- Are there multiple flowers? Where are the oldest flowers found? At the bottom or the top?
- How many sepals are there? What are their shapes and colors?
- How many petals are there? What are their shapes and colors? Are they different from the sepals?
- How do the sepals and petals attach at the receptacle? Do they alternate, or do they form a whorl?
- Can you see or count the stamens?
- Can you find the pistil?
- What is the basic shape of the flower?

By recording this kind of information, you'll begin to understand the flowers you are drawing.

69

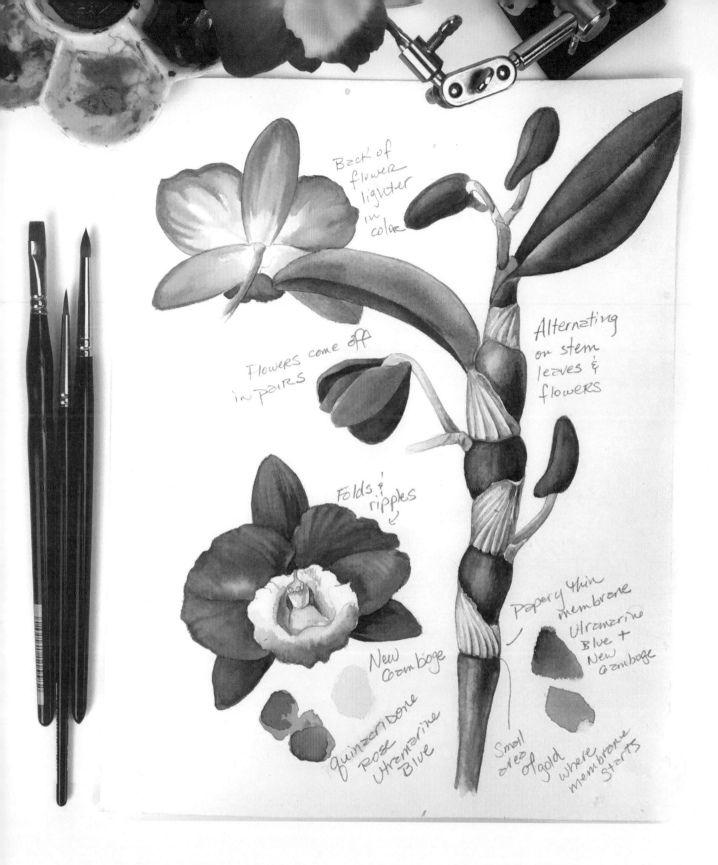

For my sketchbook page, I did a series of drawings and color notations in watercolor of different parts of an orchid. Orchids are *zygomorphic*, which means that they are bilaterally symmetrical. When drawing the flower head on, the left and right sides are mirror images of one another.

When getting ready to paint a subject, I often go to my sketchbook and draw multiple images of the same flower from bud, to slightly open, to fully open, and then dead. By recording the information at different stages, I can reconstruct the composition and decide which components I want to work with. The color notes help in remembering the colors and how to mix them later. Photographs can be used for backup, but sometimes the color is off in the photo or on a device's screen. It's best to make good color notes while the flower is alive and fresh.

Drawing a Composite Flower

The *Asteraceae*, or *Compositae*, family is one of the biggest and most common flower families, with approximately 23,000 species worldwide. A composite flower is actually one flower comprised of hundreds of flowers. The center of the flower is called the disc, and it's where the disc flowers are found. The ray flowers surround the disc flowers and are often mistaken for petals. The sunflower is the most common and recognizable composite flower. No matter where you live, you should be able to find a composite flower.

Ray Flower

Receptacle

Disc Flowers

Other Composite Flowers

Here's a brief list of other plants that are part of the compositae family:

- Chicory • Dandelion • Chrysanthemum • Dahlia
- Zinnia • Goldenrod • Aster • Thistle • Cosmos
- Black-eyed Susan

It's beneficial to draw a composite flower systematically. Because there are many components, it's easy to get lost. To fully understand the mechanics, follow the easy steps outlined here.

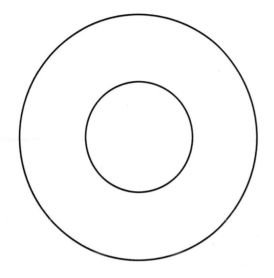

Measure the inside of the disc flowers and the outside of the ray flowers, and draw two circles.

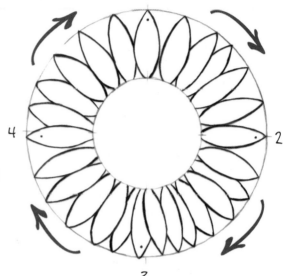

Use a permanent marker to place four dots on four ray flowers, separating the flower into four quadrants. Mark them 1, 2, 3, and 4. Draw the ray flowers in the first quadrant, counting them as you go if you want. Draw only the foreground flowers until you have gone all around the outside circle. Make sure all the flowers converge at the circle's center.

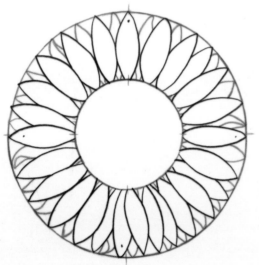

Draw the ray flowers behind the front row, but don't add any detail yet.

Place a piece of tracing paper over the drawing, and begin to draw the details. Now you can customize and have the ray flowers undulate, twist, and turn. Notice that the flowers turn just like the leaves you studied on pages 55-56. The disc flowers in the interior are too small to put into the preliminary drawing and will not transfer easily. Add the detail after the drawing is transferred onto good paper.

Patterns in Nature

The inside of a composite flower can be intimidating, but once you can identify the patterns, it becomes easier to replicate. Here are some examples of how to break down complicated patterns.

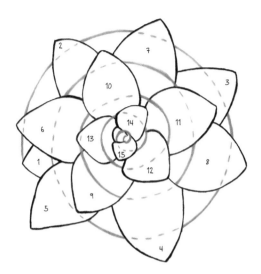

The easiest pattern to understand is one that starts at the base and makes its way to the center of the plant in the form of a spiral. Cacti, roses, and many other plants grow this way. The oldest growth is found at the base and, as the plant grows, the youngest growth is found in the center.

With more elements, the plant pattern becomes more complex. Breaking down simple lines and curves makes it much easier to understand and draw. The underside of a pinecone can be simplified into a pinwheel of swirls that originate from the center. This also is how the center of a composite flower works.

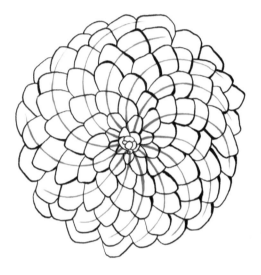

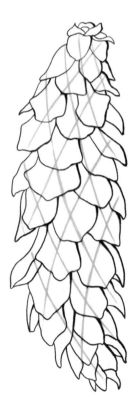

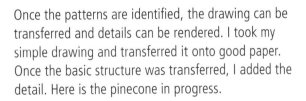

As the spirals turn from head-on to a side view, follow them by looking for rows that intersect and create diamond patterns, as in the side view of the pinecone.

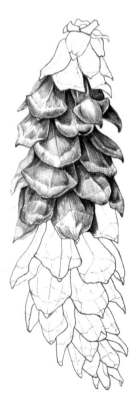

Once the patterns are identified, the drawing can be transferred and details can be rendered. I took my simple drawing and transferred it onto good paper. Once the basic structure was transferred, I added the detail. Here is the pinecone in progress.

The Habit

A plant consists of many parts: roots, leaves, branching system, and sometimes a flower. All the parts together are referred to as the "habit." In this illustration, I chose *rudbeckia*, commonly known as black-eyed Susan. I started by working with multiple stalks at varying degrees of growth. I wanted to produce a habit drawing that showed the life cycle of the plant, as well as the whole habit. The challenge was to get the whole plant and all its components into the composition. This process can be done on multiple pieces of tracing paper or in a sketchbook.

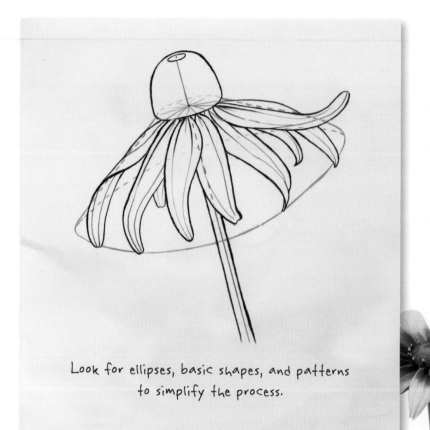

Look for ellipses, basic shapes, and patterns to simplify the process.

Once you have all the components you want for the composition, you can either retrace them or transfer the components onto final good drawing paper. Redraw and add more details. Work in graphite from the background to the foreground, and establish any elements that might work as an atmospheric fade. You can see my final drawing on the next page.

Follow these simple steps to create your own habit drawing:

- Start by drawing the flowers at different angles and different stages of growth: bud, semi-open, and mature.
- Do a rubbing of a leaf to capture the venation of the plant.
- Remove some of the disc and ray flowers from the plant, and draw them separately; become familiar with how they are arranged and attach to the flower head.
- Observe and take notes on how the plant grows. Draw aspects of how the leaves attach to the stalk.
- Lastly, uproot the plant, and draw the root system.

Incorporating Birds

Birds are found all over the world in every possible setting, from crowded city streets to rural, backcountry roads. They inhabit frozen, temperate, and tropical climates and can be seen on both land and water. The ability to fly from one location to another allows birds to migrate and be found in different environments during different seasons worldwide.

Birds are a challenging subject to draw because they move quickly, taking flight at a moment's notice, and often disappearing before a single pencil stroke is made. Understanding and breaking down basic bird anatomy will greatly enhance your experience drawing them, whether you are working from photographs, taxidermy specimens, captive birds, or observing them in the wild.

Head & Beak Shapes

Just as plants exist in a wide range of shapes, sizes, and colors, birds are equally diverse. Each bird has a special way of gathering food. The first clue to look for is the shape of the head—especially the beak. The shape of the bill or beak lets you know something about its eating habits. Is the beak short or long, curved or pointed, flat or hooked? Each shape determines if the bird eats seeds, insects, fruit, nectar, meat, carrion, or fish. Here are some general shapes to look for and how they are specially designed for collecting food.

Beak Variations

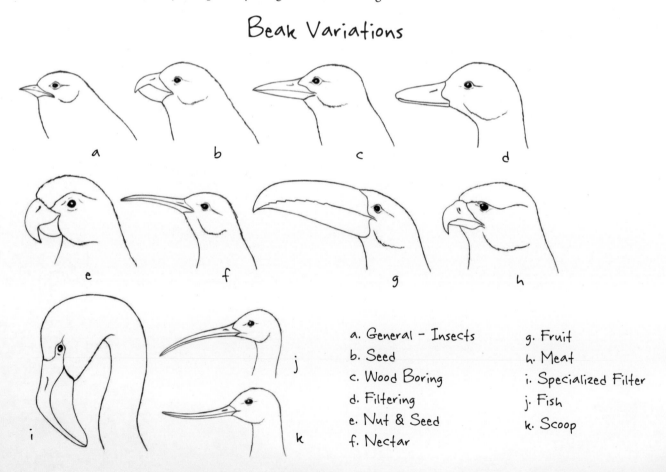

a. General – Insects
b. Seed
c. Wood Boring
d. Filtering
e. Nut & Seed
f. Nectar

g. Fruit
h. Meat
i. Specialized Filter
j. Fish
k. Scoop

Feet

Bird feet are also specialized and help define the habitat where the bird resides. Special adaptation of the feet allows species to perch, grab, swim, climb, and even walk on water! Most birds have four digits, which are similar to human toes. The arrangement of the digits often helps classify what type of environment they live in. Here are some common bird feet arrangements.

Basic Bird Feet

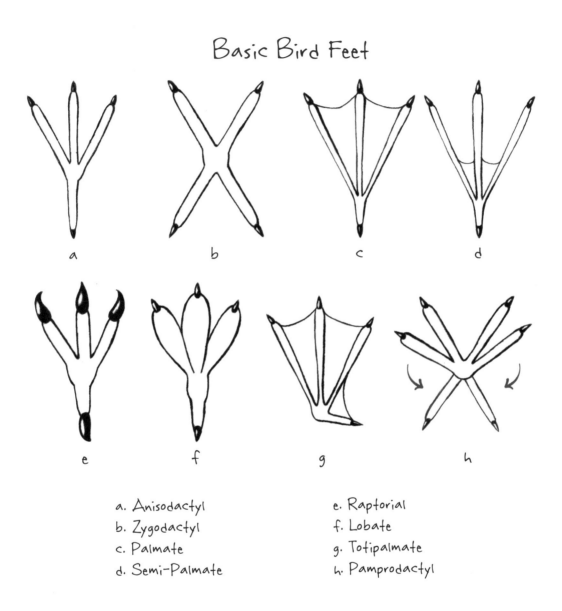

a. Anisodactyl
b. Zygodactyl
c. Palmate
d. Semi-Palmate

e. Raptorial
f. Lobate
g. Totipalmate
h. Pamprodactyl

The largest group of birds belongs to the *Passerine* family. This group is generally described as birds that can perch. Most perching birds have an *anisodactyl* toe arrangement. There are three toes in the front and one toe in the back, which allows them to wrap their feet around branches and stems. Songbirds, such as finches, buntings, and sparrows, have this toe arrangement.

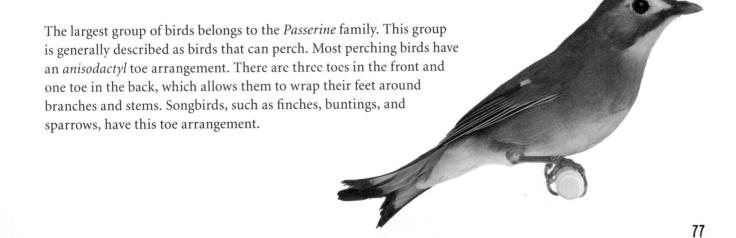

The second most common arrangement of toes is *zygodactyl*. There are two toes in the front and two toes in the back. Birds with this arrangement are likely to climb up and down trees and use this configuration for support. Woodpeckers, parrots, and owls commonly have this toe arrangement.

Birds that swim normally have a *palmate*, or webbed, foot. There are three toes in the front with webbing between the front toes and one toe in the back, which is not webbed. A semi-palmate arrangement means three toes are only partially webbed. Ducks, geese, and other swimming birds have this toe arrangement.

A *lobate* foot is an adaptation of the webbed foot. Instead of having skin between the toes, there is extra skin on the front three toes, which are wide and flat. Grebes typically have this toe arrangement. Take a look at the photo shown here. See the difference between the feet on this grebe and the webbed feet of a duck?

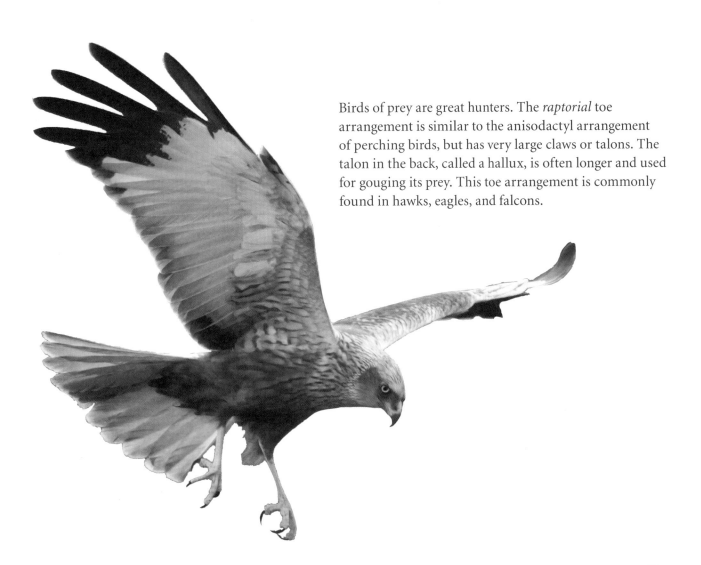

Birds of prey are great hunters. The *raptorial* toe arrangement is similar to the anisodactyl arrangement of perching birds, but has very large claws or talons. The talon in the back, called a hallux, is often longer and used for gouging its prey. This toe arrangement is commonly found in hawks, eagles, and falcons.

Another variation is the *pamprodactyl* arrangement. In this configuration, the first and fourth toes can pivot. This helps the bird hook onto areas like cliffs and cave walls. Swifts are the most common type of bird with this toe arrangement.

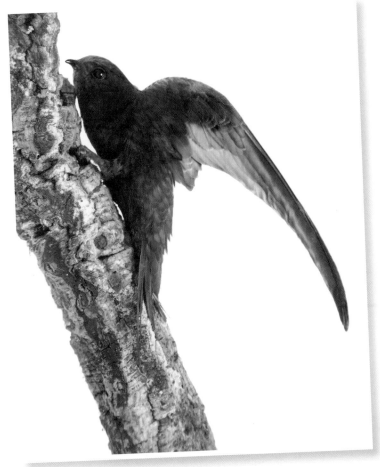

Feathers

Birds are the only animals that are covered in feathers. Feathers have many functions, including protection from the elements of heat, sun, and water. They provide color for camouflage and attracting a mate. In conjunction with the skeletal structure, feathers also make it possible for a bird to take flight.

There are two common types of feathers. Contour feathers are the most common, as they are found all over the body, including the tail and wings. Down feathers are typically found underneath contour feathers and are not visible. They waterproof and insulate the bird. The quill is where the feather attaches to the body, and it's similar in appearance to the midrib on a leaf.

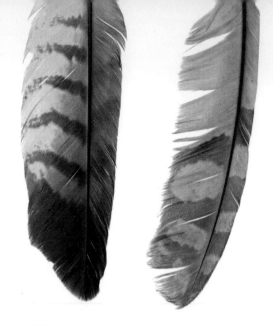

Feather Variations

The barbs are individual, hairlike structures that come off the quill. Each barbule has microscopic hooks that interlock with one another.

Here is a diagram of two typical contour feathers and their parts. On the left is a contour feather with the quill equidistant from each side. On the right is a contour feather that has a variation, with the left side of the quill narrower with a notch and the right side wider. This variation is often found in the primary feathers on the wing.

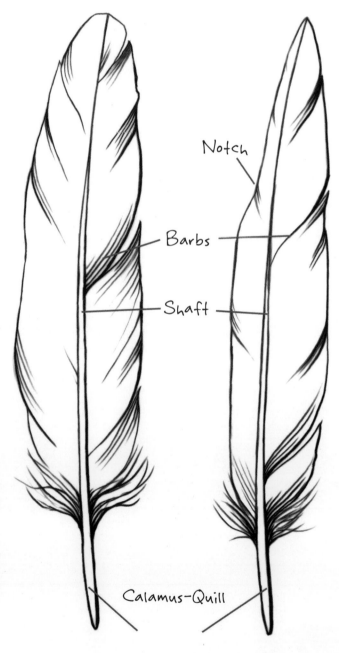

Notch

Barbs

Shaft

Calamus—Quill

Peacock Feather

One of the most remarkable birds is the male peacock. Its tail feathers are designed to attract and impress a potential female for mating. Each tail feather consists of an eyespot and an arrangement of dazzling color. The beauty of these feathers has made them popular and readily available in the home décor and craft industry—they can easily be purchased for drawing reference.

For this demonstration, the light source again plays an important role in getting the colors to shimmer, creating iridescence. Here you can see how I used my "helping hands" to hold the feather at the base. I placed it against a large piece of white paper and set up my light source at 11 o'clock and 45 degrees from the picture plane.

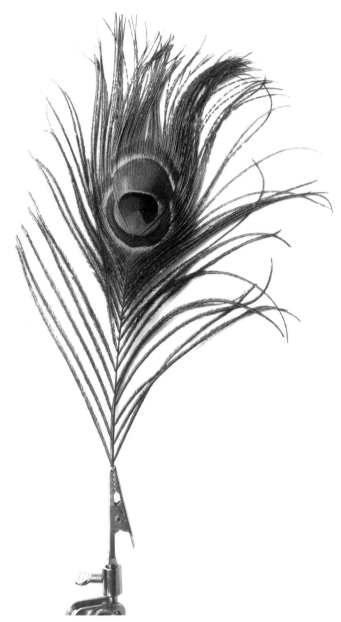

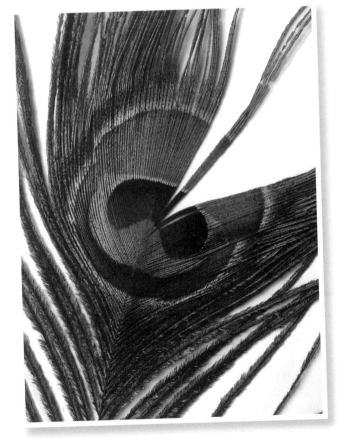

It's important to notice that each individual barb has a series of colors. When put together, the colors create the eyespot. In this detail photo, I separated the barbs to show how the color changes from the quill to the end in a series of stripes.

Color Study

In this demonstration, I'm working on double-frosted mylar (called Dura-Lar by Grafix) with colored pencil. To get acquainted with how the colors morph into one another, I created a series of tonal scales to show the transition. I looked at different areas of the feather and split them into three separate color gradations.

First draw the basic outlines for each color shift around the eye spot on tracing paper. If you're working on mylar like me, secure the mylar on top of the tracing paper with removable tape to keep it in place. The underdrawing shows through the opaque mylar, so there is no need to transfer the drawing.

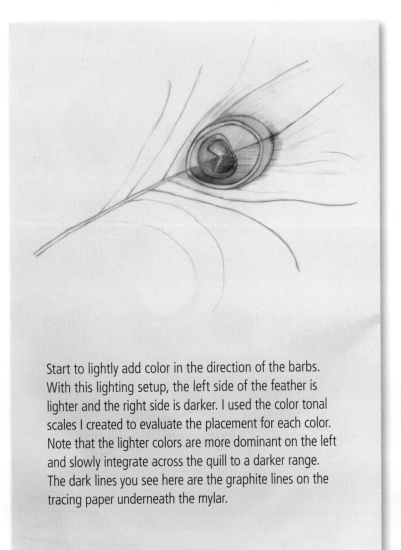

Start to lightly add color in the direction of the barbs. With this lighting setup, the left side of the feather is lighter and the right side is darker. I used the color tonal scales I created to evaluate the placement for each color. Note that the lighter colors are more dominant on the left and slowly integrate across the quill to a darker range. The dark lines you see here are the graphite lines on the tracing paper underneath the mylar.

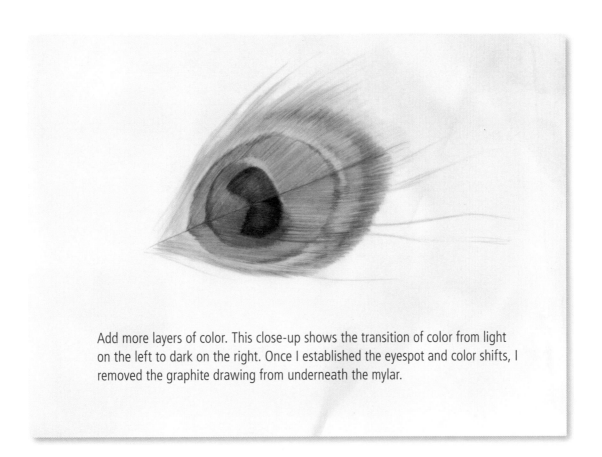

Add more layers of color. This close-up shows the transition of color from light on the left to dark on the right. Once I established the eyespot and color shifts, I removed the graphite drawing from underneath the mylar.

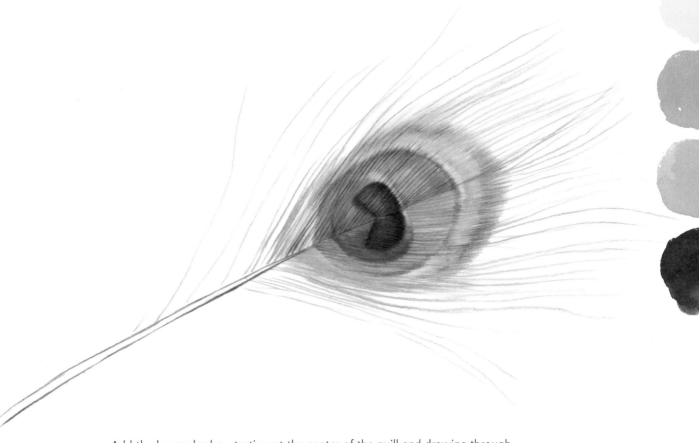

Add the longer barbs, starting at the center of the quill and drawing through the eyespot to the outside perimeter. Use one continuous line with a darker, contrasting color to the define the detail and integrate the color shifts. The darker line represents the space between each barb.

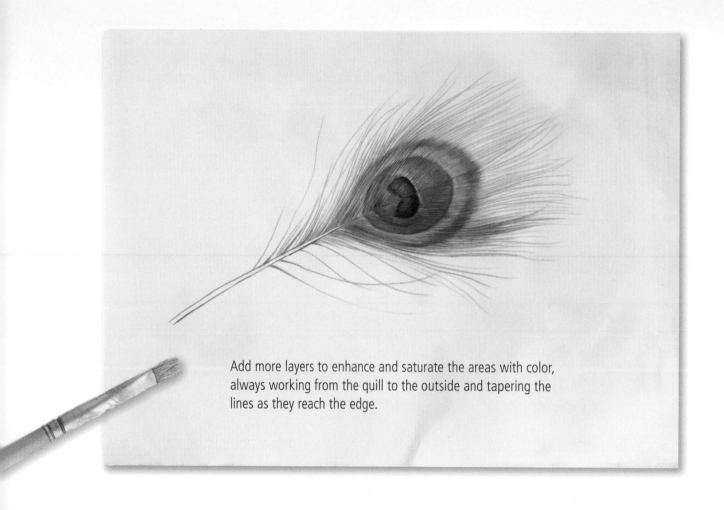

Add more layers to enhance and saturate the areas with color, always working from the quill to the outside and tapering the lines as they reach the edge.

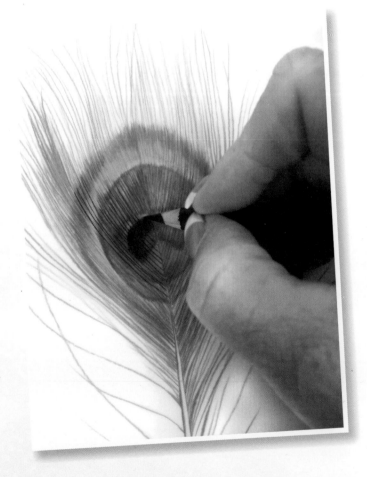

One of the wonderful things about working on double-frosted mylar is that both sides can be used. It can be challenging to know if you should go darker with the color application. If you add more layers and it's not what you wanted, it's difficult to backpedal and remove layers. This is where the flip side comes in! I decided that I wanted to make the right side darker and blacker, but I wasn't sure how dark to go. I flipped the mylar over and darkened in the right side (which is on the left when flipped). If it got too dark, I could always erase the back without damaging my work on the front.

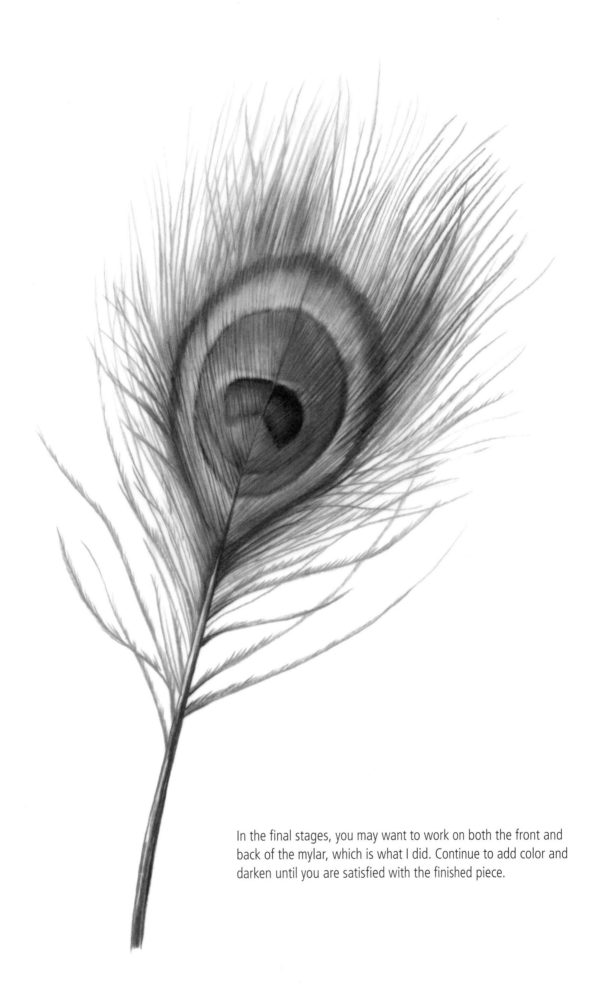

In the final stages, you may want to work on both the front and back of the mylar, which is what I did. Continue to add color and darken until you are satisfied with the finished piece.

Wing Bone Structure

The basic bone structure of a wing is similar to that of the human arm. The humerus is the upper arm. The radius and the ulna make up the forearm and connect at the humerus. This connection is what we would consider the elbow. The radial and ulnare are the wrist. The wrist connects to the main section of the hand, the carpometacarpus. There are only two digits: the pollex, which is considered the thumb, and the phalange, which is a fused finger. From the base of the digits, carpometacarpus, and radius is the alar, which is the feather tract.

The bones in the wing are hollow, which makes them lightweight. This intricately designed wing is what gets birds into the air.

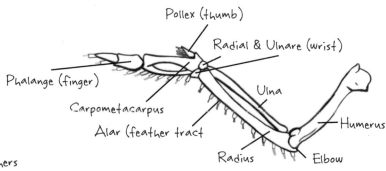

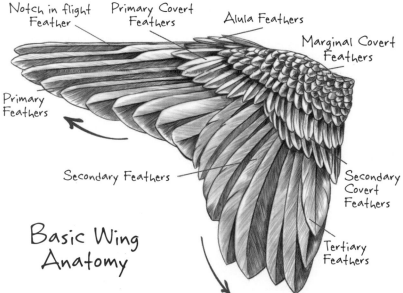

For this diagram, I illustrated a mallard duck wing. The feather arrangement on the wing consists of primary, secondary, covert, and alula feathers. The primary feathers usually consist of 10 contour feathers, which attach at the carpometacarpus and phalange bones. The feathers that extend the furthest from the body may be notched and asymmetrical. Closer to the body, the feathers become symmetrical.

The secondary and tertiary feathers attach at the radius and vary in number.

The alula feathers attach at the pollex, or thumb. This small grouping of feathers can move independently and helps navigate a bird's flight direction. The covert feathers cover the primary and secondary feathers and become incrementally smaller as they get closer to the body.

An important aspect of the wing structure is how it folds up into a resting position. The wing hinges at the radial and ulna, or wrist. When the bird opens its wings to fly, the primary feathers spread open like a fan away from the body, as do the secondary feathers, but in opposite directions, indicated here by the red arrows.

You can legally purchase wings on the Internet or at a local shop. Never work from a deceased bird you find on the road, in your yard, or on hiking trail, as it may carry disease. It's also illegal to own feathers or parts of certain birds that are a protected or endangered species—even if you find an animal that has perished you have no proof that you didn't end its life. Heavy fines can be levied if you are caught with possession of a bird, even if you think it is common to your area.

How Wings Fold

In the resting stage, birds hold their wings close to their body. The primary feathers fold under the secondary feathers. Use the color key shown here to understand the movement, indicated by the colored lines in the diagrams below. See how the secondary feathers cover the primary feathers? Only the bottom half of the primary feathers is visible when the bird is in a resting position.

Color Key

- Primary Feathers
- Secondary Feathers
- Tertiary Feathers
- Alular Feathers
- Tendon

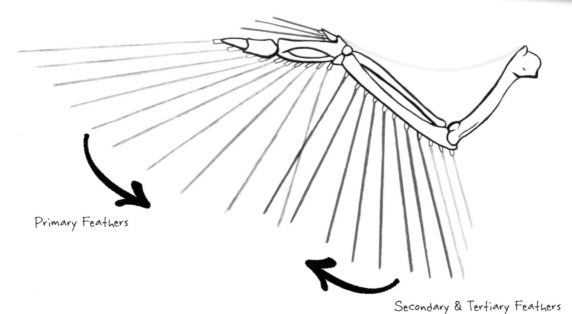

Primary Feathers

Secondary & Tertiary Feathers

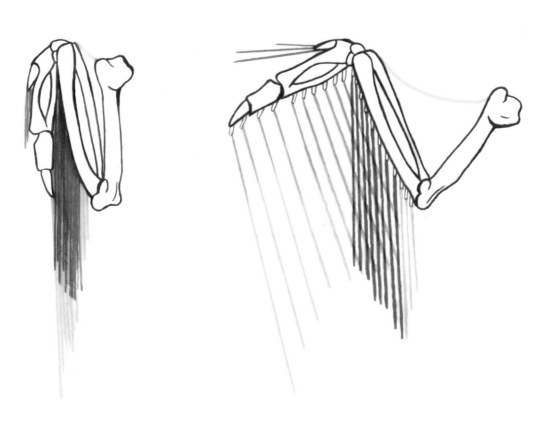

Basic Skeletal Structure

There are a few important things to be aware of when drawing birds. One is how the head attaches to the neck and spine. Birds have very flexible necks. In the resting position, it forms the shape of an "S." This is especially apparent when looking at birds with long necks, such as flamingos, herons, and cranes.

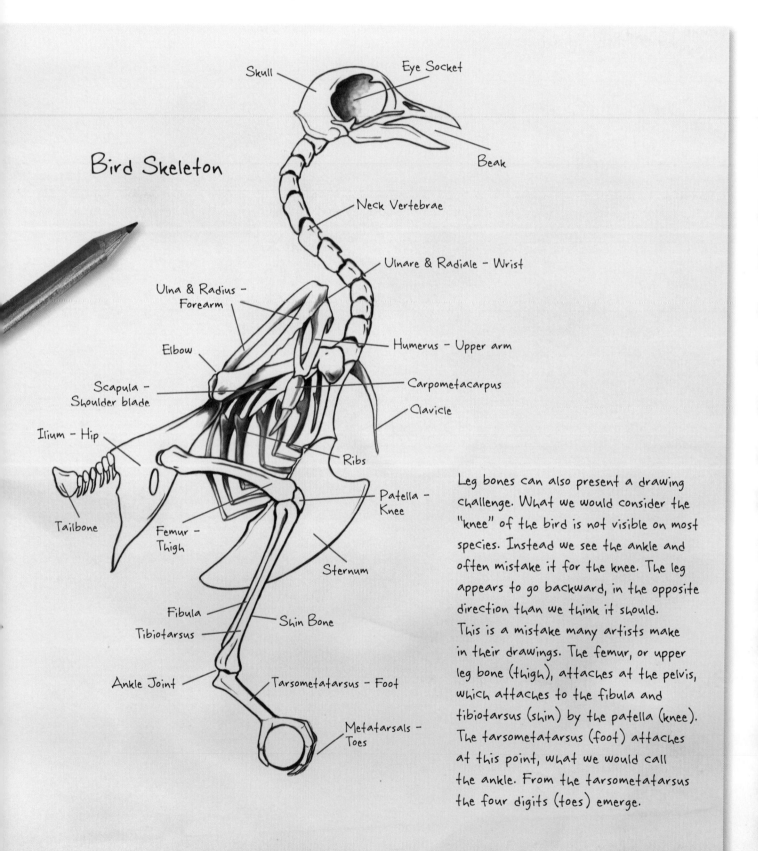

Bird Skeleton

Skull
Eye Socket
Beak
Neck Vertebrae
Ulnare & Radiale – Wrist
Ulna & Radius – Forearm
Humerus – Upper arm
Elbow
Carpometacarpus
Scapula – Shoulder blade
Clavicle
Ilium – Hip
Ribs
Patella – Knee
Tailbone
Femur – Thigh
Sternum
Fibula
Shin Bone
Tibiotarsus
Ankle Joint
Tarsometatarsus – Foot
Metatarsals – Toes

Leg bones can also present a drawing challenge. What we would consider the "knee" of the bird is not visible on most species. Instead we see the ankle and often mistake it for the knee. The leg appears to go backward, in the opposite direction than we think it should.
This is a mistake many artists make in their drawings. The femur, or upper leg bone (thigh), attaches at the pelvis, which attaches to the fibula and tibiotarsus (shin) by the patella (knee). The tarsometatarsus (foot) attaches at this point, what we would call the ankle. From the tarsometatarsus the four digits (toes) emerge.

Sketching Birds

Birds are everywhere—but almost impossible to get close to! If you do get close, they move or fly away. This is both challenging and frustrating. The basic anatomy here gives you an overview of what you should look for. Here are some ideas for ways you can practice drawing birds.

Taxidermy Specimens

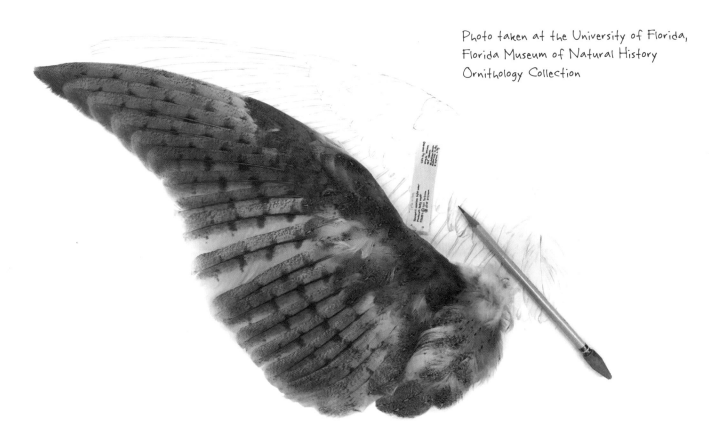

Photo taken at the University of Florida, Florida Museum of Natural History Ornithology Collection

Natural history museums, local wildlife centers, universities, and even taxidermists are great places to sketch birds. Some institutions have bird skins, which means the interior of the bird has been removed and the body cavity filled with cotton or other material. Such places may also have bird wings, skulls, and other body parts that can be useful to see up close and personal. These kinds of things are usually kept in climate-controlled drawers and are not often on display to the public. You can request permission to see them with a phone call to the collections manager.

Mounted specimens are prepared with a core-manufactured skeleton, on which the skin is mounted. The positions can be very lifelike. Museums may also have displays in dioramas, showing the birds in a replicated habitat.

Drawing from different angles will help you gain confidence. This can be valuable when cross-referencing information from other sources, such as photographs. It's easy to miss small details in the field or photographs.

Live Birds in Captivity

Zoos and wildlife rehabilitation centers offer a great opportunity to see live birds from around the world. They are also typically in enclosures with limited area for flight, making them much easier to draw than in the wild.

Live Birds Outdoors

Local parks, especially parks with ponds, streams, or other bodies of water, are a great place to find birds. A backyard bird feeder may also be a perfect place to see birds. Any place available where you can sit quietly and observe them is recommended. Even if you're not sketching, just observing how they take to flight and land and interact with one another will add important information to your knowledge of birds.

When planning an outdoor drawing excursion, bring minimal sketching gear, a camera, and binoculars—don't forget a bottle of water!

Working from Photographs

Many artists work from photographs when drawing birds. The pro is that the bird doesn't move. The con is that photographs can distort perspective, rendering body parts out of focus or hidden by foliage. I highly recommend working from your own photographs; it's unethical to copy a photograph taken by someone else, even as a drawing or painting, and claim the work as your own.

You don't need to have expensive camera equipment or be a good photographer. Sometimes my photos are out of focus or poorly composed. Look at this example of a poor photograph I took of a great green macaw. I was observing how it preened its feathers and took several photos. This photo was out of focus, but I liked how the head was positioned peeking out over the wing. Using my knowledge of bird anatomy, I was able reconstruct it and create a colored pencil drawing. I changed the format from vertical to horizontal, expanded the wing, and changed some of the color markings of the bird.

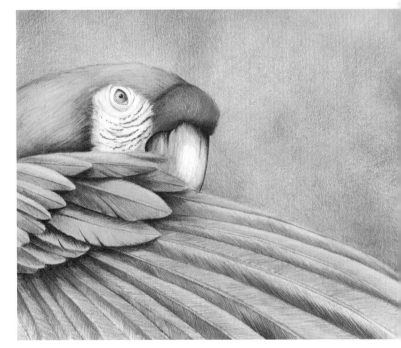

Pinterest

Years ago, I had a photo reference library comprised of pages torn from wildlife magazines. I created folders and labeled them by species. As I accumulated images my folders turned into filing cabinets full of photos. I no longer have these paper files. I donated them to an art center, and now I use my iPad and Pinterest in the same way. If you're not familiar with Pinterest, you need to open an account today! This online database allows you to upload, share, and organize digital images of every kind. I use it as an art reference library. Each time I start a project of a specific bird, I search the Internet and Pinterest for images using keywords of what I am looking for. I "pin" them onto designated boards and continue to collect them. Whenever I need a specific trait or body part, I can go to the appropriate board and look at several views, close-ups, and detail shots to enhance my work. While it's unethical to copy someone else's photograph, using photos for reference to fill in the gaps of missing information is perfectly acceptable and useful.

You may have a friend who takes great photos and is willing share them with you. If you use a friend's photos to create a painting, it's a good idea to get written permission from the photographer and credit them where your work appears.

91

Gesture Drawing

Sketching birds in pencil is the best way to get started. It allows you to erase lines, correct proportions, and fix posture. When starting a bird drawing, whether from life, specimens, or photographs, it's important to start with the basic shapes. Some artists are fascinated with details and spend their beginning efforts carefully drawing small details. However, this can lead to disaster if the overall proportions and perspective are incorrect. It's better to start with the basic shapes of the head, body, tail, and legs, and then add the eye, beak, wing, and feet. After these proportions are correct, add the color markings and other details. In short, get the basic anatomy correct first, and then refine the drawing and add details.

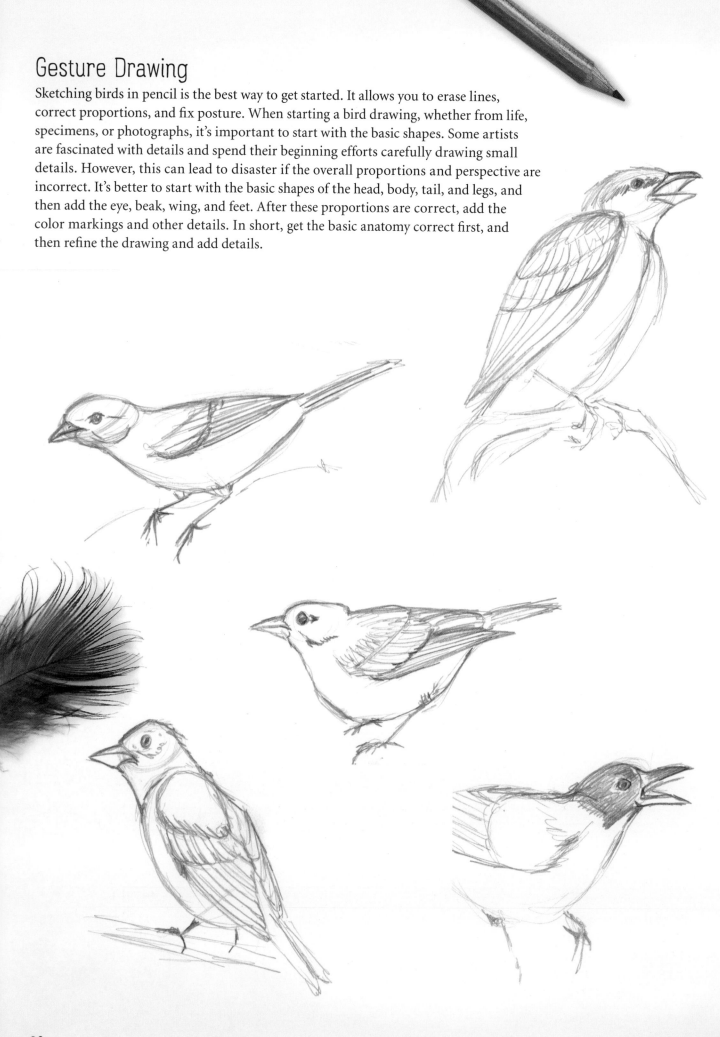

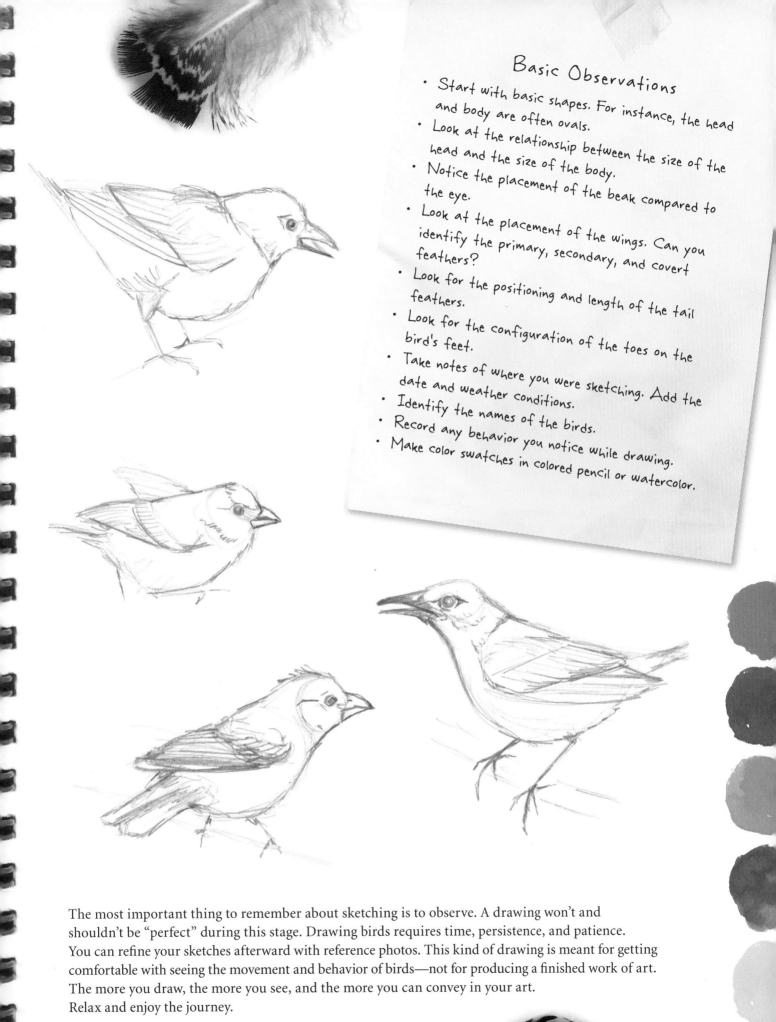

Basic Observations

- Start with basic shapes. For instance, the head and body are often ovals.
- Look at the relationship between the size of the head and the size of the body.
- Notice the placement of the beak compared to the eye.
- Look at the placement of the wings. Can you identify the primary, secondary, and covert feathers?
- Look for the positioning and length of the tail feathers.
- Look for the configuration of the toes on the bird's feet.
- Take notes of where you were sketching. Add the date and weather conditions.
- Identify the names of the birds.
- Record any behavior you notice while drawing.
- Make color swatches in colored pencil or watercolor.

The most important thing to remember about sketching is to observe. A drawing won't and shouldn't be "perfect" during this stage. Drawing birds requires time, persistence, and patience. You can refine your sketches afterward with reference photos. This kind of drawing is meant for getting comfortable with seeing the movement and behavior of birds—not for producing a finished work of art. The more you draw, the more you see, and the more you can convey in your art.

Relax and enjoy the journey.

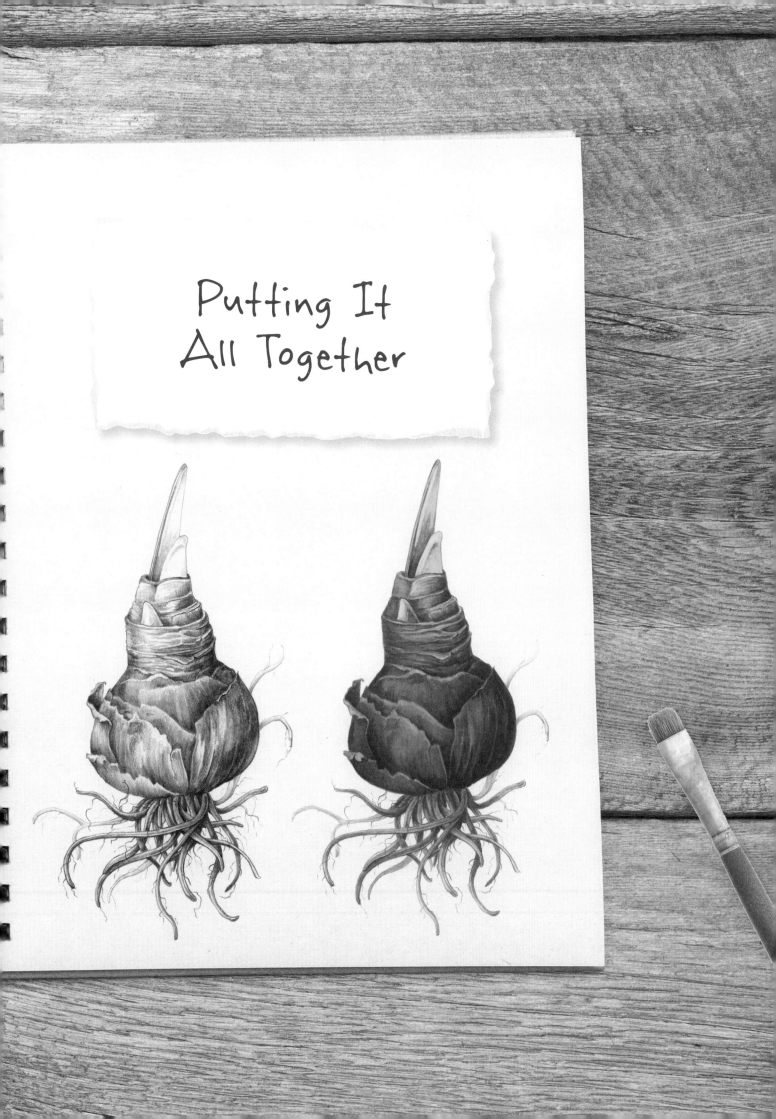

Putting It All Together

Developing an Idea

How does a painting become a reality? For me, it usually starts with discovering something new. Whether I am walking in my neighborhood, kayaking on a river, or traveling abroad, I'm always on the lookout for my next inspiration. I carry my digital camera and my sketch journal with me when I am specifically going out to explore and capture nature on paper and photographs. I often find that my cell phone is very valuable as a source of recording information, because it allows me to take photos of things at the spur of the moment. Being ready when you least expect it can be very rewarding.

Digital photographs taken with a smartphone can also capture your location when you took the pictures. This can be helpful later if you need to go back to a location for more research. If appropriate, I collect samples of plant material to bring home with me for further drawing and painting. Never collect anything that is on the endangered species list. Leave the wild, just that...wild.

Collecting & Organizing Information

After the initial discovery, I head to my computer and the Internet. Technology has made it possible to get information immediately. Be careful when researching things on the Internet, however. Cross-reference information and, if possible, do your search using the Latin names of plants and birds. As I learn more about my subjects I compile a text document of everything I find interesting and where I found the information. The more I research, the more I want to know. I may go to the library to search for more specific books on my topics. I create preliminary sketches to work out ideas. Sometimes I may decide to do a life cycle of a plant, and this process can take a year before I ever put paint to the paper. It's best to get organized right from the beginning.

As an idea develops I create a folder and put all the information in the folder with a date and title on the front. I can add to this as the year continues. Not all my ideas end up in paintings, but it's better to have too many ideas than not enough!

Starting the Composition

Once I have enough information to start a painting, I gather all the information and begin. There are many factors to consider before starting.

Considerations

- Size and format. What will be the finished size of the painting? Will it be a vertical or horizontal format?
- Am I painting this for a specific reason? Perhaps to show the life cycle, or am I creating it as a commission, or for a commercial client?
- What medium do I want to work in? Do I need to experiment with different media before I take the plunge?
- How many elements will be in the composition?
- Do I have enough drawings and angles from different positions? Do I need more, or can I eliminate some?

Tracing Vellum Once I have decided these things, I begin working on a piece of tracing vellum slightly larger than the painting will be. I really like working with tracing vellum, because it allows me to move my components around the area. I temporarily tape the elements in place underneath the large piece. They can be rearranged or flipped in reverse. Besides researching the project, I spend the most time figuring out the composition. I find it must "read" properly. Every stem, feather, and flower must be understandable in the composition.

If you intend to frame your paintings for yourself, a juried exhibition, or a private client, it's a good idea to consider the size and framing costs. I learned very quickly that painting to fit my work into standard-sized frames saved me a huge amount of money. I picked four standard sizes in which to do my paintings, which actually gives me eight options: four landscape, and four portrait. Working to a specific size allows me to buy an inexpensive or custom frame, but not be stuck with having to custom-frame my work to a special size. Standard sizes vary in different countries. Check out standard sizes in your local art and framing stores for choices.

From Sketch to Final Color

Colored pencil is a natural transition from working in graphite to working with color. The skills used are the same! Adding color is all about color mixing, following surface contour, and creating harmony. Create your own still life scene to render step by step, or follow along with my example.

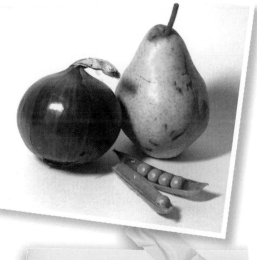

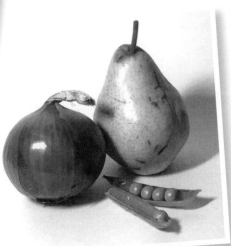

Set up a still life of fruits and/or vegetables, and illuminate it with 11:00-at-45-degree lighting. Take a picture with your smartphone or digital camera, and convert the image to grayscale to see the tonal values.

Find interesting colors, textures, and shapes for your still life. Start simple, and then progress into more complex challenges as you get comfortable with your skills.

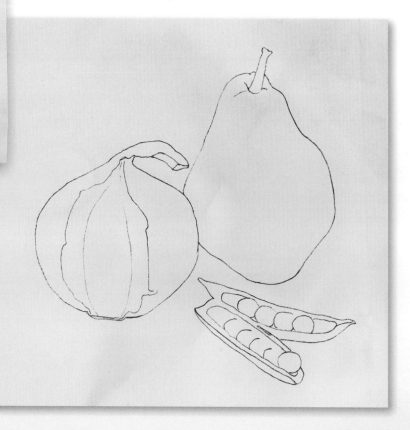

Draw the basic shapes on tracing paper. It's not important to add details at this point; just focus on a pleasing composition and getting the perspective right.

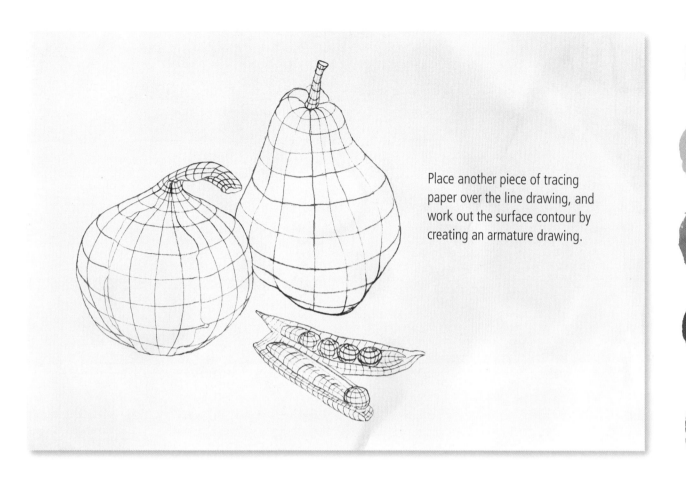

Place another piece of tracing paper over the line drawing, and work out the surface contour by creating an armature drawing.

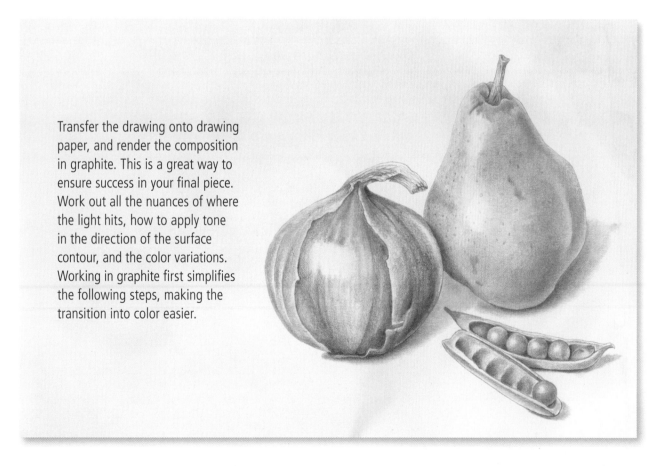

Transfer the drawing onto drawing paper, and render the composition in graphite. This is a great way to ensure success in your final piece. Work out all the nuances of where the light hits, how to apply tone in the direction of the surface contour, and the color variations. Working in graphite first simplifies the following steps, making the transition into color easier.

Color Mixing

Before starting the final color rendering, I recommend creating a color scheme and palette. This composition contains four colors to consider: the red onion, the green pear, the green peas and pod, and the cast shadows. First determine the local color of each object, and then create a continuous tonal scale to extend the range of the local color to include highlights, middle, and shadow ranges.

Red Onion: The local color is pomegranate (PC195). I created a value scale by adding peacock green (PC907), indigo blue (PC901), and Tuscan red (PC937). This is a complementary color scheme.

Peas and Pod: The local color is grass green (PC909). I created a value scale by adding yellow ochre (PC942), olive green (PC911), apple green (PC912), and dark green (PC908). This is an analogous color scheme.

Pear: The local color is lime peel (PC1005). I created a value scale by adding lemon yellow (PC915), green ochre (PC1091), goldenrod (PC1034), yellow ochre (PC942), and true blue (PC903). This is an analogous color scheme.

Shadows: The local shadow color is a neutral gray, but rather than use a gray colored pencil, I mixed two complementary colors: pomegranate (PC195) and peacock green (PC907). These colors appear in the other objects and add unity, creating overall color harmony.

*Note: The top half of each tonal scale is burnished with white (PC938), and the bottom half of each scale is burnished with a colorless blender.

Transfer the basic drawing from tracing paper onto good paper. I used a light box to transfer the drawing onto hot-pressed, 140-lb. watercolor paper. Use corresponding colored pencils to suggest the light source in the outline. For example, I drew the left side of the onion in pomegranate (PC195) and the right side in indigo blue (PC901). Variation in the line color prevents dark outlines on the edges of the objects.

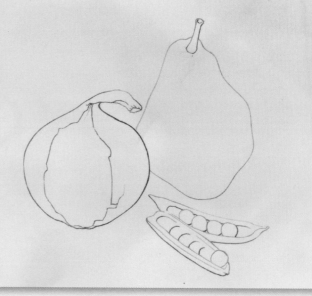

The tonal values of the interior should always match the tonal values of the outline.

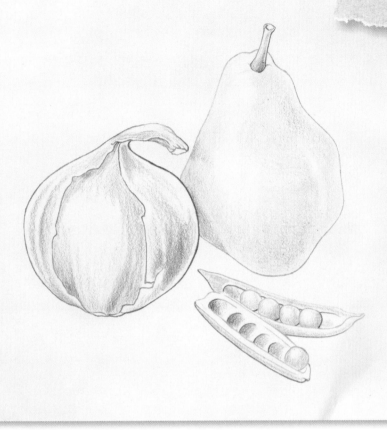

Begin creating form in a monochromatic color scheme for each object. Use the graphite tonal drawing on page 99 as a guide. Leave the white of the paper for the highlights.

Using your continuous tonal color samples, begin to layer in color to darken and strengthen the forms.

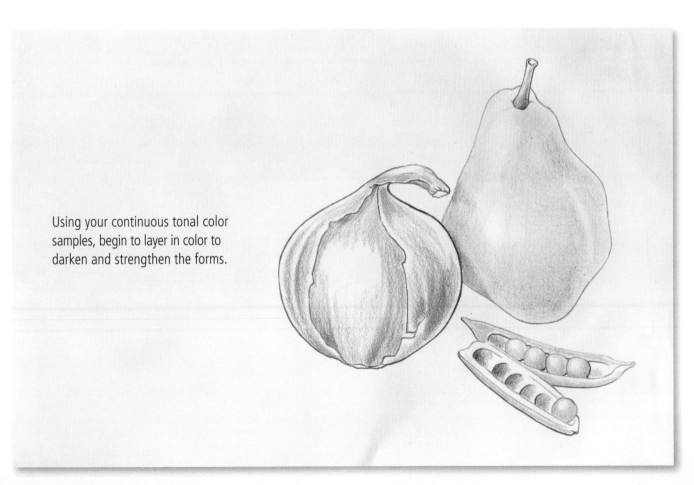

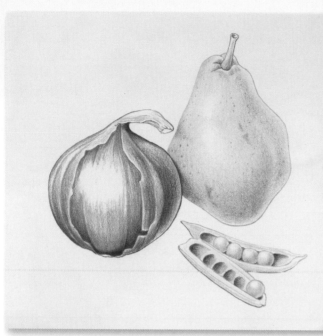

Deepen the dark and midtone areas by slowly alternating layers of color for each object. Begin to add variations of color to create interest and detail.

Use a colorless blender to burnish each object. This intensifies the color and removes most of the texture of the paper.

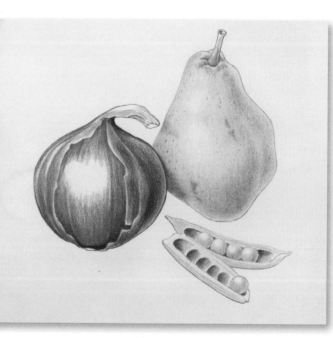

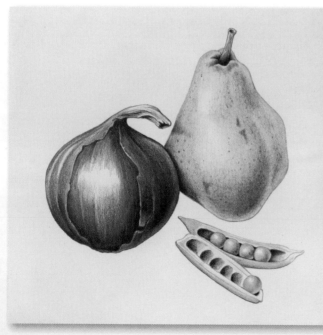

Create harmony by using the same color in each object. To strengthen the concave areas in the pea pods, I applied a layer of pomegranate (PC195). I also used this color to create the onion's cast shadow on the pear. Add more layers over the colorless blender to deepen and add detail.

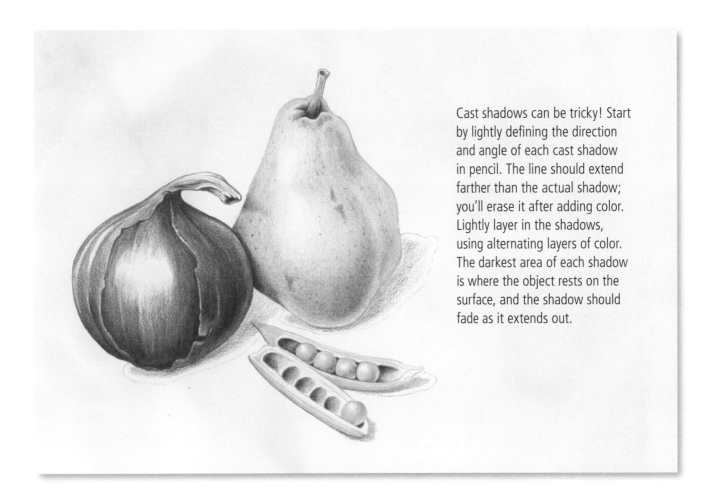

Cast shadows can be tricky! Start by lightly defining the direction and angle of each cast shadow in pencil. The line should extend farther than the actual shadow; you'll erase it after adding color. Lightly layer in the shadows, using alternating layers of color. The darkest area of each shadow is where the object rests on the surface, and the shadow should fade as it extends out.

Erase the pencil outline. Finish the drawing by adding any additional details. Careful planning results in a successful finished drawing. Understanding perspective, surface contour, lighting, texture, and color mixing are all part of a work of art!

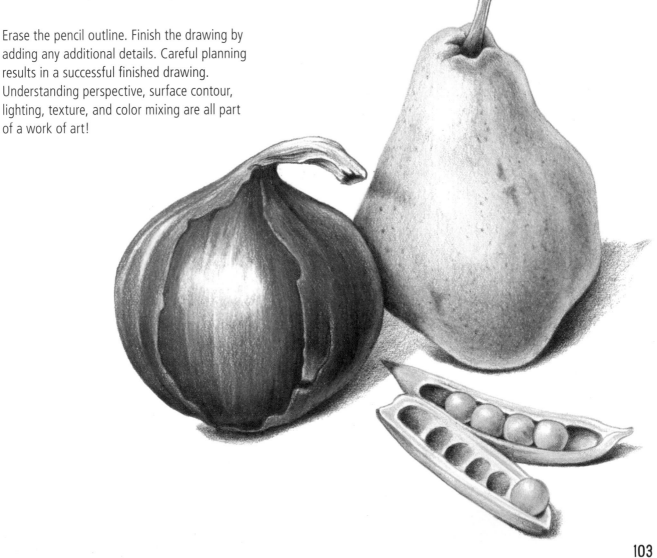

Hummingbird & Pink Flamingo Heliconia

During my travels to Costa Rica, I have collected sketches and photographs over the years of tropical hummingbirds and heliconias. My favorite heliconia is the pink flamingo heliconia, or *Heliconia chartacea*. It's a pendulum heliconia, which means the flower droops over the stalk. This is in the same family as the bird of paradise, which is considered an erect heliconia—the flower is upright.

In researching heliconias, I found out they are pollinated by hummingbirds. For this painting, I decided to do a simple composition of a crowned woodnymph, *Thalurania colombica*, resting on one of the bracts on the flower. To identify the hummingbird, I went to a field guide on the birds of Panama, and then cross-referenced it with the Latin name on the Internet. Below are the reference photos I used for the drawing.

Establishing the Composition

On tracing paper, I refined and drew the hummingbird. I usually start by drawing larger than I want the finished piece to be, which helps me render the details and see things easier in the beginning stages. Hummingbirds have very small features, and I find it challenging to get the anatomy in the right place—drawing the bird larger helps in the process of erasing and correcting. I also draw on both sides of my tracing vellum to refine and correct lines. Once I liked the drawing, I used my all-in-one printer to reduce the image to my desired size.

I decided to work this composition in a portrait format, due to the long, thin nature of the heliconia. In looking at other photo references, I decided I could shorten the stalk, so I chose to make the painting 10" × 14" to fit in a standard 16" × 20" frame with a 3-inch mat around the painting. In the tradition of botanical illustration, I decided to work with a white background and have just the two elements of flower and bird in the composition.

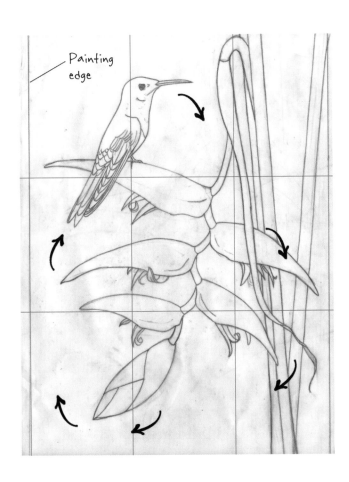

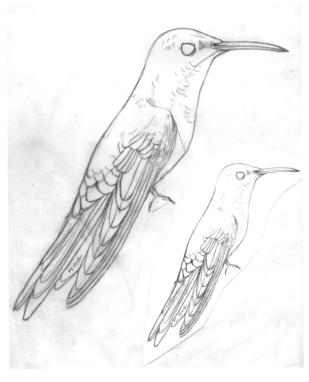

In this composition, I used the rule of thirds. I placed the bird in the upper left, perched high on the first bract. To add grace and movement in the painting, I curved the bottom of the unopened bract to sweep up toward the bird. The tilted position of the stalk leads the eye from the bird down to the right, toward the bottom, and then up again, as indicated by the arrows.

In observing hummingbirds in the wild and at feeders, I have found that the best way to see them is to stay very still. These birds are very fast, and it's impossible to "chase" them. They are also territorial and will fight for nectar. The best way to observe them is to find where they perch—a favorite spot they return to for rest. This is usually a high position, so they can view their surroundings.

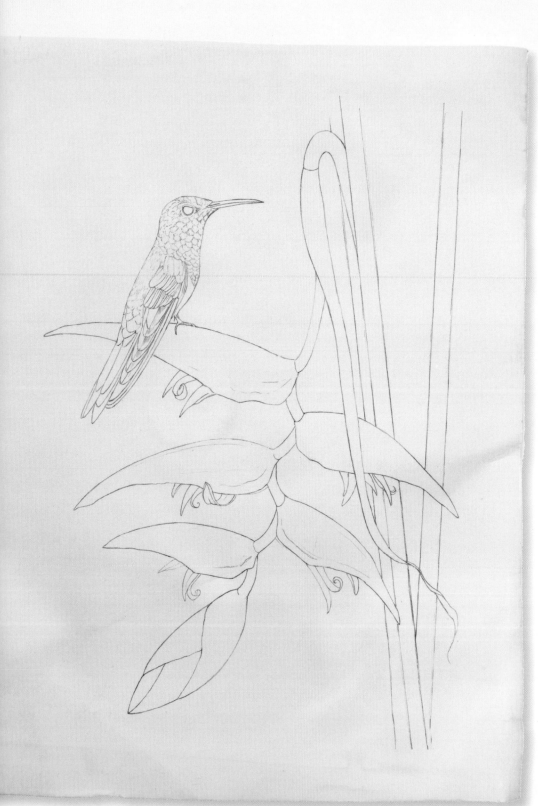

I used the smaller copy of the hummingbird to make the size of the flower and the hummingbird accurate and proportional to one another. At this point, I don't focus on creating major details. My objective is to get the composition solidified to transfer onto good paper, which is a piece of 140-lb. hot-pressed watercolor paper.

I traced the back of the drawing with an HB drawing pencil and then flipped it over and placed it on the good paper to trace it. Once on the watercolor paper, I refined the drawing and added the details of the bird's plumage.

Once you have determined the composition and are ready to move on to good paper, be sure to cut the paper larger than the actual size it will be. I recommend at least a 1-inch margin larger than the composition. I paint outside the margin to ensure that any areas that will be cropped out of the painting are painted past the edge of the mat. This is referred to as a "bleed."

Mixing Colors

I almost always work a painting from the background to the foreground. For this painting, the bird is sitting on top of the flower, and the stalks are behind the flower. I started by mixing my watercolors to make sure they were the right color, strength, and properties.

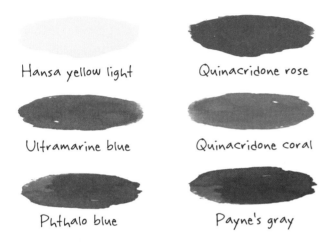

Hansa yellow light

Quinacridone rose

Ultramarine blue

Quinacridone coral

Phthalo blue

Payne's gray

*Note: These colors are from Daniel Smith.

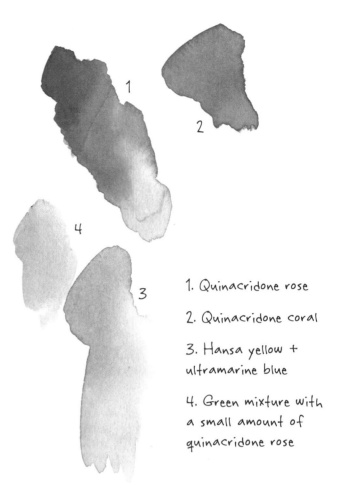

1. Quinacridone rose

2. Quinacridone coral

3. Hansa yellow + ultramarine blue

4. Green mixture with a small amount of quinacridone rose

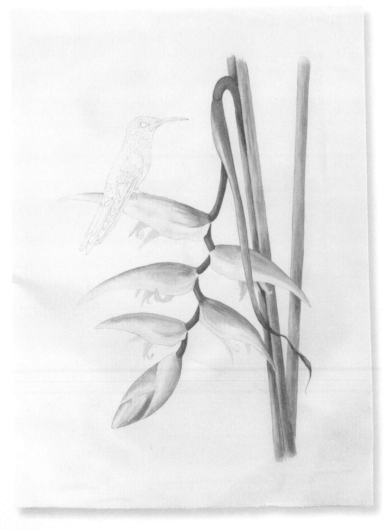

First Layers

I started on the green stalks, with a light mixture of hansa yellow and ultramarine. I wet the paper for each stalk and dropped the color in the shadow areas, working left to right. Then I began working on the flower. Starting at the top, I worked my way down using a watery mixture of quinacridone rose for the main portion of the bracts, along with my green mixture. I painted the stem with a mixture of quinacridone rose and coral. For the small flowers emerging from the underside of the bract, I used the same green mixture, with a bit more hansa yellow added.

If you're right-handed, it's best to work from left to right so you aren't moving your hand across a wet area you just painted. If you're left-handed, start at the right and work left. In other circumstances, you can work from the top of the painting down. If you rotate the paper, be mindful not to place your hand on an area with wet paint.

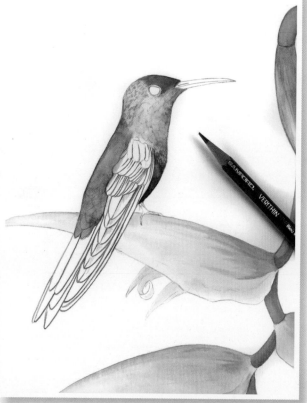

Hummingbird

The brilliant colors of the hummingbird must start with the brightest and clearest colors possible. I used hansa yellow, as it is a brilliant yellow that leans green, and phthalo blue, which is a vibrant, intense green-blue. Combined, they create a beautiful emerald green. I mixed ultramarine with phthalo blue for a nice variation of blues for the crown area.

I started by wetting the head and using a small spotter brush to add hansa yellow to the highlight areas, letting it bleed. I added phthalo blue while it was still wet to create green in the areas where the head is in shadow. Then I added two blue mixes to the top of the head toward the beak.

Before going on to the rest of the bird, I created a mixture of emerald green and used the spotter brush to lightly add more depth, detail, and color into the area.

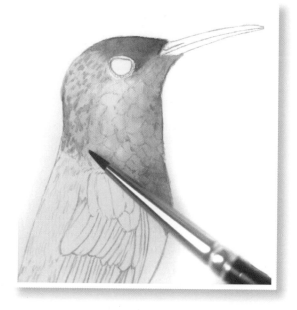

I continued to work the back and the belly of the bird in the same manner. The belly is in shadow, so I dropped darker paint on this side.

To ensure I didn't lose the detail of the feathers, I went back over my pencil drawing with a Premier Verithin Prismacolor indigo blue pencil. Graphite can smear and get messy when water is applied on top. The Verithin pencils have a harder lead than regular colored pencils. The wax in the colored pencil resists the water and prevents the lines from getting smeared or blurry. I chose indigo blue because the bird has many shades of blues.

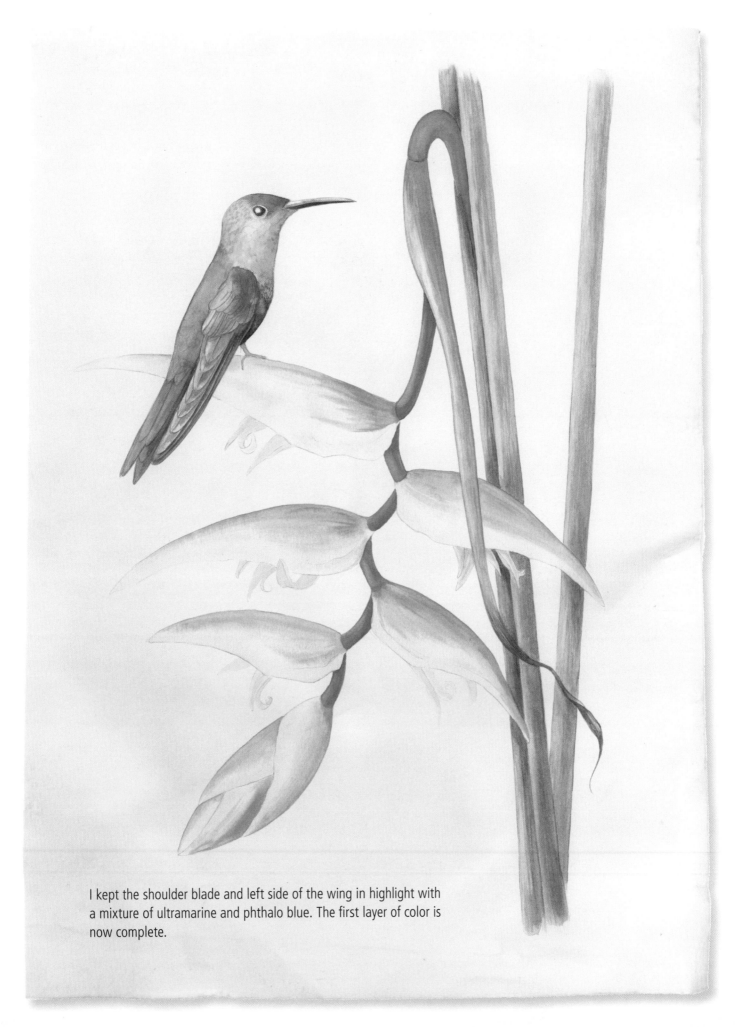

I kept the shoulder blade and left side of the wing in highlight with a mixture of ultramarine and phthalo blue. The first layer of color is now complete.

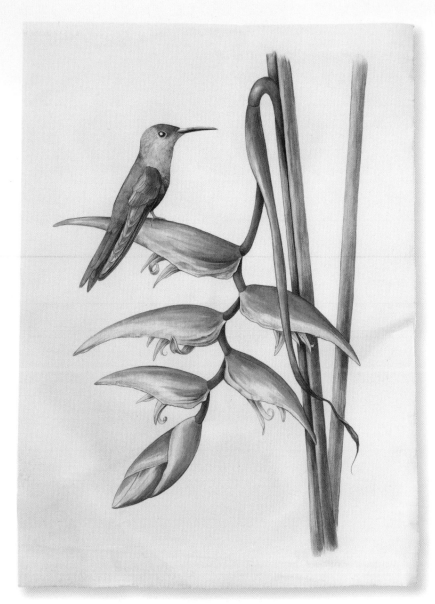

Second Layers

For the next layers, I used a spotter and drybrush technique. This is almost like using a pencil. The brush is very small, and I built up color with layer upon layer of paint. At this point I added more shadows and detail, starting on the green stalks and systematically working from the top to the bottom bract. I used fine lines to define the edges of the bracts so they would disappear into the painting. Avoid outlining too dark, which will cause you to lose the form.

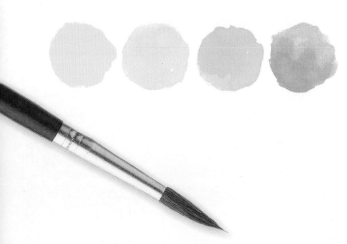

Before going on to the rest of the bird, I created a mixture of emerald green and used the spotter brush to lightly add more depth, detail, and color into the head area.

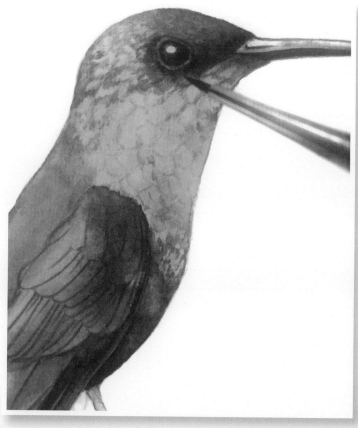

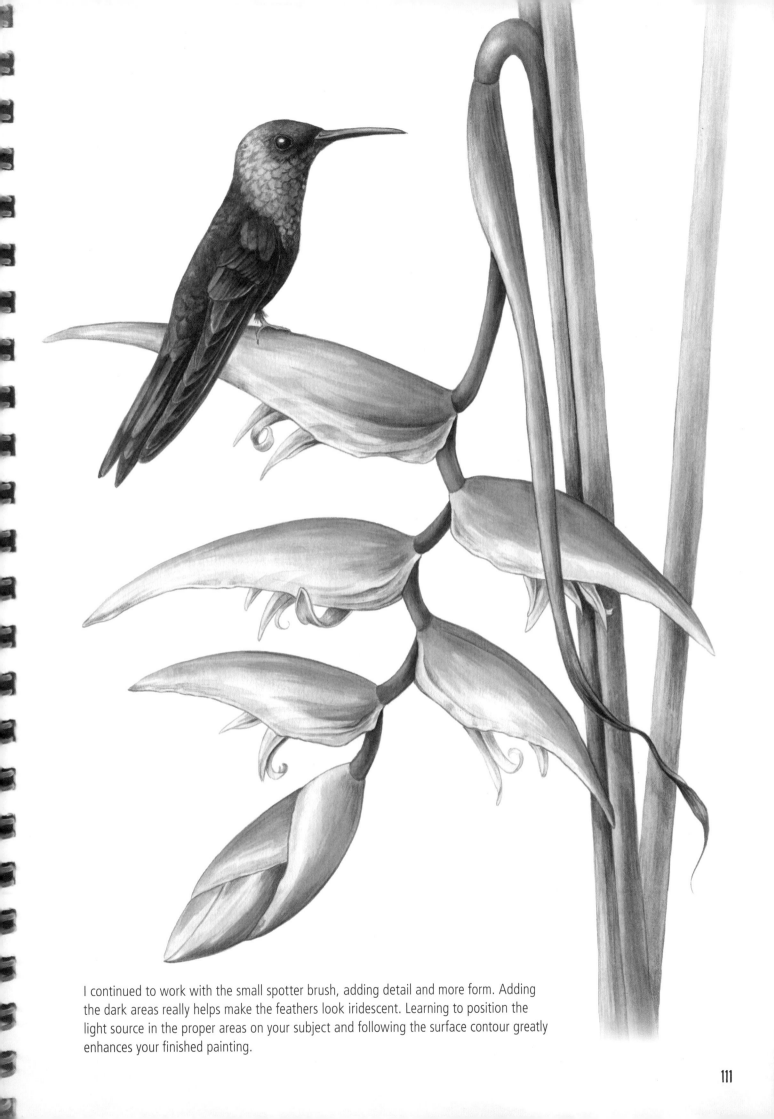

I continued to work with the small spotter brush, adding detail and more form. Adding the dark areas really helps make the feathers look iridescent. Learning to position the light source in the proper areas on your subject and following the surface contour greatly enhances your finished painting.

Toucan & Papaya

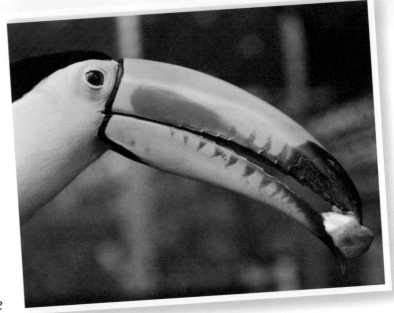

This painting is an example of one that was compiled over several years. My experiences and travels to the tropics are something I have been doing for more than 25 years, and each time I go I discover something new and fascinating. Remember that gathering research, experience, sketching, etc. can take a long period of time. A few years ago, I witnessed a group of small aracaris gorging themselves on a papaya tree. After doing a little research, I discovered these birds are related to the toucan, and their bills are specifically designed to dig into the flesh of fruits like papaya. They ingest both the fruit and seeds. This is a very important relationship, because the toucan disperses the papaya seeds for future generations.

I wanted to create a painting of this encounter. I gathered all my photo references and realized I didn't have enough information for the papaya tree to do an accurate drawing. Luckily, I live in Florida, so I went to a grower and purchased a papaya tree.

After creating a leaf rubbing, I knew that the drawing would need to be large to get all the information in—papaya leaves are huge! I decided to change the bird from an aracari to a toucan, because I had more sketches and photos—including a nice shot of the toucan's blue feet!

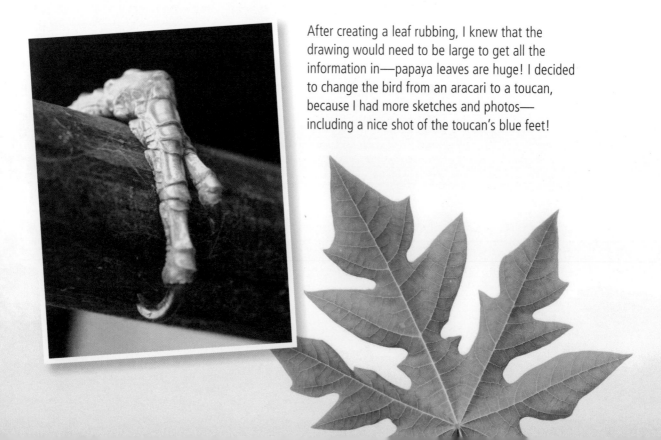

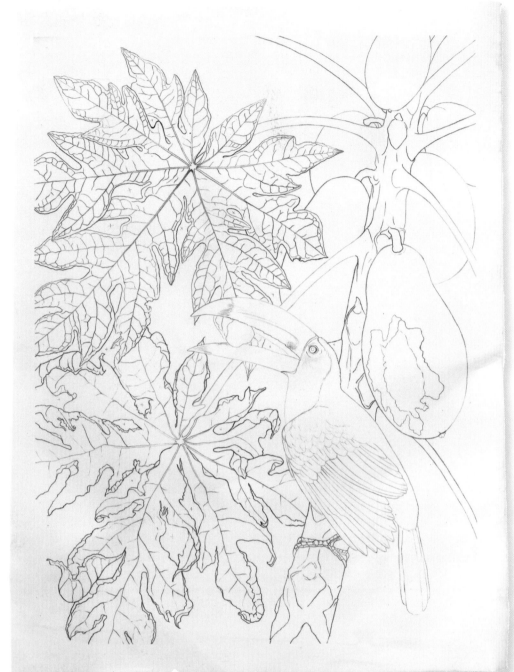

Initial Outline

I transferred the drawing onto watercolor paper with minimal detail. As I redrew the drawing, I added the details and used a variety of Verithin colored pencils to create the outlines. For instance, on the top leaf I used light and dark green pencils to draw the leaf margin and the venation. I used the lighter green in the highlighted areas and the darker green in the shadow areas. I also varied the pressure of the pencil lines to create movement by making the lines thick and thin. Once the entire drawing was refined and the detail added in, I started to add color and form to each segment with watercolor pencils.

I worked out the composition on a 20" x 26" piece of tracing velum using lots of different elements. I arranged them underneath the larger sheet of paper until I came up with a composition I liked. For this painting, I worked in Staedtler watercolor pencils, Prismacolor Premier colored pencils and Verithin colored pencils, and a colorless blender on extra-white, hot-pressed, 300-lb. watercolor paper. I chose the heavier-weight paper because it can handle a lot of layers and doesn't bend or wrinkle as easily. I cut the paper larger and used removable tape to secure it to a thick piece of foam board. This makes it easy to work on without fear of bending or creating folds in the paper.

Colors Used:

Staedtler Karat 25 Professional Watercolor Pencils	Prismacolor Verithin
1 Yellow	Indigo blue
16 Golden ochre	Black
19 Dark ochre	Olive
2 Red	Orange
4 Orange	Brown
9 Black	
77 Warm sepia	**Prismacolor**
76 Van Dyke brown	Black
73 Burnt sienna	White
57 Olive green	Cream
55 Green earth	Colorless blender
53 Lime green	
36 Indigo	
31 Glacier blue	
33 Blue	
6 Violet	

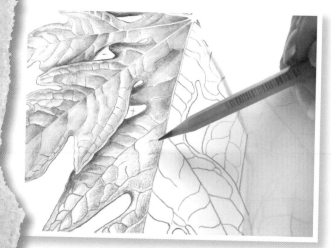

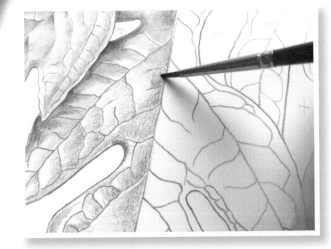

Dry Application Followed by Water

I laid the first application of watercolor pencil dry. Keeping my light source in mind, I used light green and dark green to create volume and color. Then I applied water on top to blend.

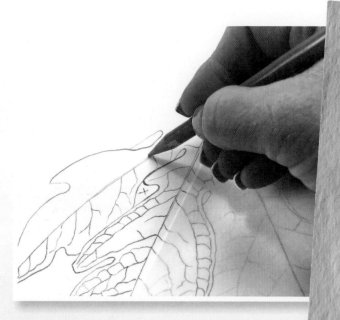

Place an "X" in the negative space between areas of a leaf or other elements in your drawing to keep your place. You don't want to fill in an area that should be left blank. Make sure the mark is very light, so you can erase it later. When working on a large painting, place a piece of tracing paper under your hand to avoid smearing. The tracing paper is translucent so you can still see the drawing progress underneath, while also protecting it from smearing.

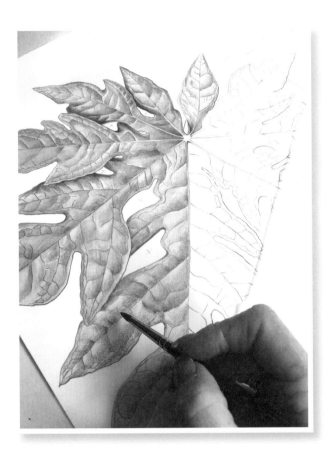

I continued working from the top of the left side of the leaf downward, varying the amount of pressure and greens, making sure to leave highlights to show the puckering of the leaf.

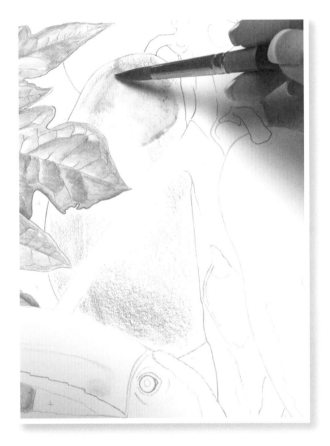

The Papayas

I added color to the papayas in the same manner as the leaves, starting out dry and then adding water to the paper. This time I used the side of the watercolor pencils, instead of the point, to lay down big areas of color and form, following the surface contour of each papaya. I introduced golden ochre to add interest to the papaya. My reference photos showed a lot of variation in color, and this helped me make each one unique and not compete with the leaf. I used a #10 watercolor brush to apply water—the larger brush size made it easier and faster to achieve a smooth, even wash.

The tree that I purchased was a great asset in learning about papaya leaves and how they join to the trunk, as well as how the papayas grow from the tree. The tree was very young and had one tiny papaya growing. To expedite the painting process, I purchased a mature papaya at the grocery store so I could see the texture and color variations on the outer skin, as well as the interior with the seeds. This was helpful, as the photographs I had did not show enough detail. The best part was eating the papaya after I was done drawing and painting it!

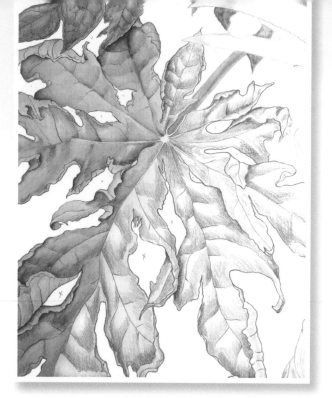

Crinkled Dead Leaf

I wanted to add another leaf to my composition, but I also felt that the amount of green in the painting would be overwhelming. It was just my luck some of the leaves on my papaya tree were yellowing, curling, and turning brown. I modified the leaf drawing to add more curls and ripples. I worked the leaf with the same two greens as the fresh leaf and integrated golden ochre, as well as some brown, to show the leaf is in decline.

Blocking in the Toucan

I worked on the trunk of the tree first, to prepare for starting the toucan. Black can be a tricky color. To give the bird's feathers sheen, it's important to leave bright highlights and undertones of blues and purples. The beak of the toucan is brilliantly colored, and it's important that the colors not collide and create "mud." The throat and part of the chest is a bright sunny yellow. I started out lightly with the shifts of colors on the bill. I placed the yellow, being sure to leave highlights in place. Then I used the black pencil in the shadow areas, and I placed blues and purples close to the highlight area.

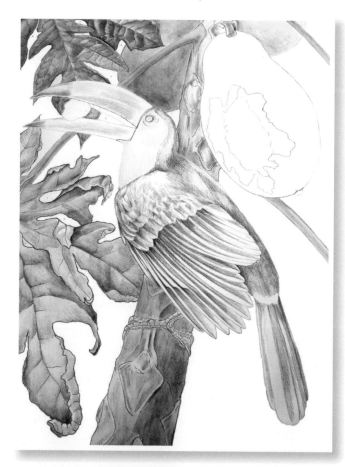

Next I went over the areas, section by section, with clear water, using a smaller round watercolor brush. The color became much more intense with the addition of water.

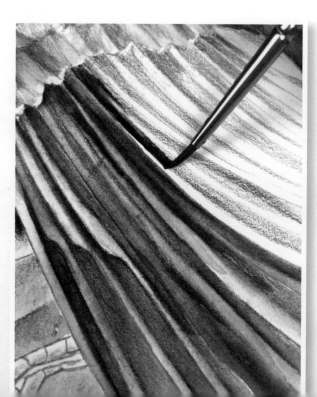

The Eye: The Window of the Soul

The eye is the most important factor in making a living subject come to life on paper. The highlight in the eye gives life to the subject. Place the highlight in the upper left quadrant of the pupil to create the greatest contrast.

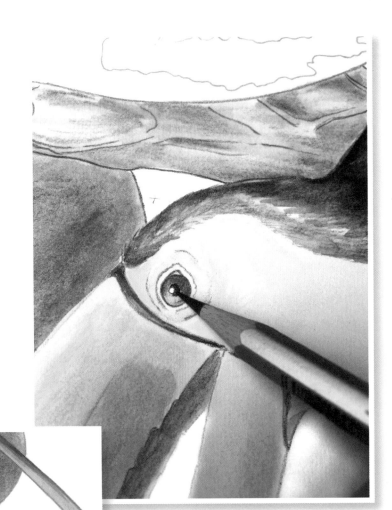

Open Papaya

The inside of the papaya is a beautiful orange color. I wanted to show the "flesh" of the inside, with the seeds exposed and some falling from the fruit to show dispersal. The toucan uses the tip of its beak to jab and tear away chunks of fruit. To show the concave nature of the inside of the fruit, the lighting is opposite with the highlights on the right and not the left. I used a purple pencil to add the shadow areas to create color harmony—this same purple is also in the black feathers. To make the round, black seeds shiny, I started with browns and then added black, making each one a tiny sphere.

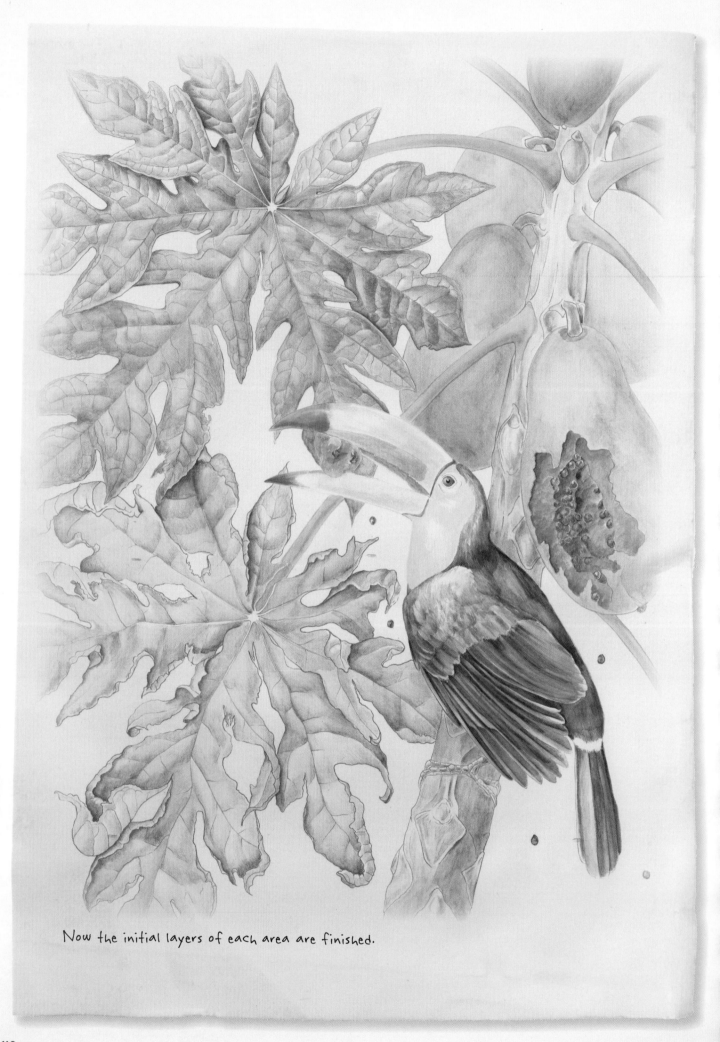

Now the initial layers of each area are finished.

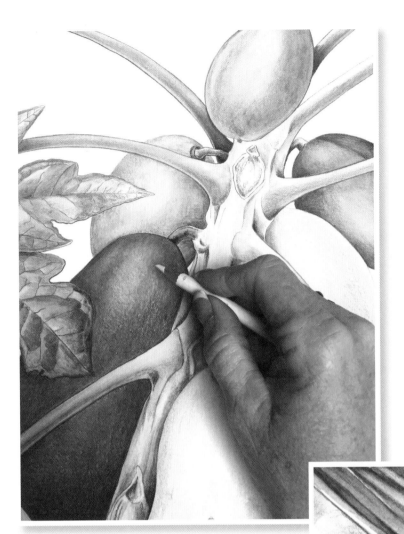

Creating Depth & Detail

The next phase is to create greater depth by increasing the form and color variation. To eliminate the texture of the paper, I worked back and forth between watercolor pencils and colored pencils. Using cream, white, and a colorless blender I burnished the color, which eliminates the texture of the paper and blends the colors together.

To make sure the toucan is stable on the tree trunk, I placed a cast shadow on the underside of the foot.

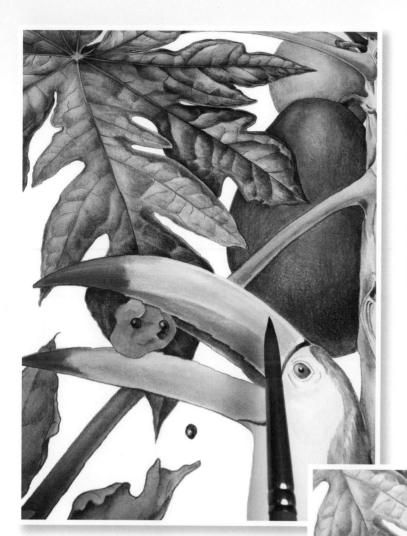

I strengthened the colors in the beak and added color and seeds to the chunk of papaya. Then I gently applied a coat of clear water with a large round watercolor brush horizontally to follow the surface contour of the beak. This intensified the colors, while not bleeding into one another. Next I shaded the inside of the mouth with purple. Note how the tree trunk, papayas, and leaves are now emerging with greater depth from the background to the foreground.

To start strengthening the black, I alternated more layers of blues and purples in the highlighted areas, overlapping areas with the black colored pencil. The outline of the feathers was originally done in colored pencil and is still visible, so I don't lose the wing configuration.

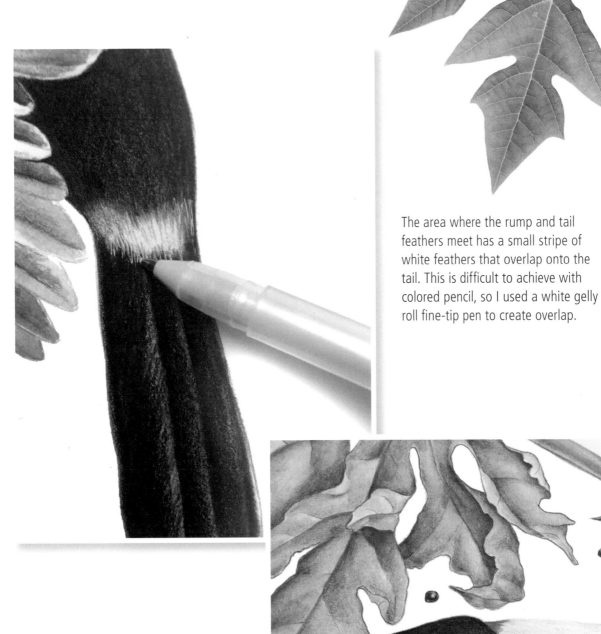

The area where the rump and tail feathers meet has a small stripe of white feathers that overlap onto the tail. This is difficult to achieve with colored pencil, so I used a white gelly roll fine-tip pen to create overlap.

Wax Bloom

The undertonal colors are emerging through the layers of black. I alternated using Prismacolor black, indigo blue, and purple, burnishing the area with a colorless blender.

As the paper begins to saturate, a hazy cast appears over the illustration. This is called a wax bloom, and it occurs when the wax separates from the color and sits on top.

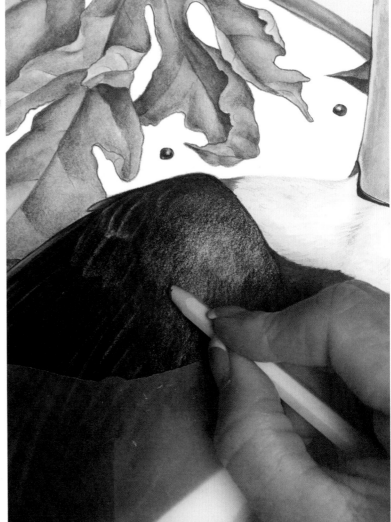

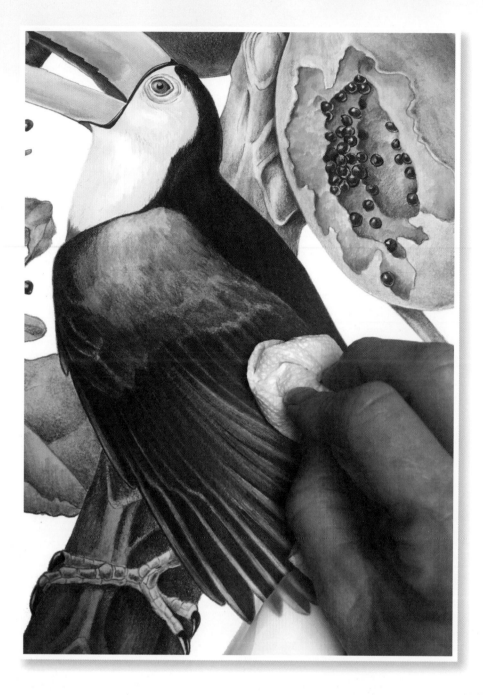

To eliminate the wax bloom, I bunched up a small piece of paper towel and went across the whole body of the bird in a circular motion, avoiding the white of the paper and the yellow area of the throat. As I applied more layers of colored pencil, I used the paper towel to buff wax bloom as it appeared. I repeated these steps over and over again until all the details were in place. The final painting you see on page 123 was scanned on an Epson® Perfection V500 scanner. There were 12 scans that overlapped, due to the size of the paper. I used an automated tool in Adobe® Photoshop® to "stitch" the 12 scans together.

Creating Digital Files

After every painting is complete, I scan my art and stitch the scans together in Photoshop. Having a scan of my work means I can reproduce it for fine art prints, greeting cards, and other products. I have several backups for each painting. Never store your images in only one place. If your computer crashes or the one backup drive you have breaks, you can lose your work. I use external hard drives, thumbnail drives, and online "cloud" storage.

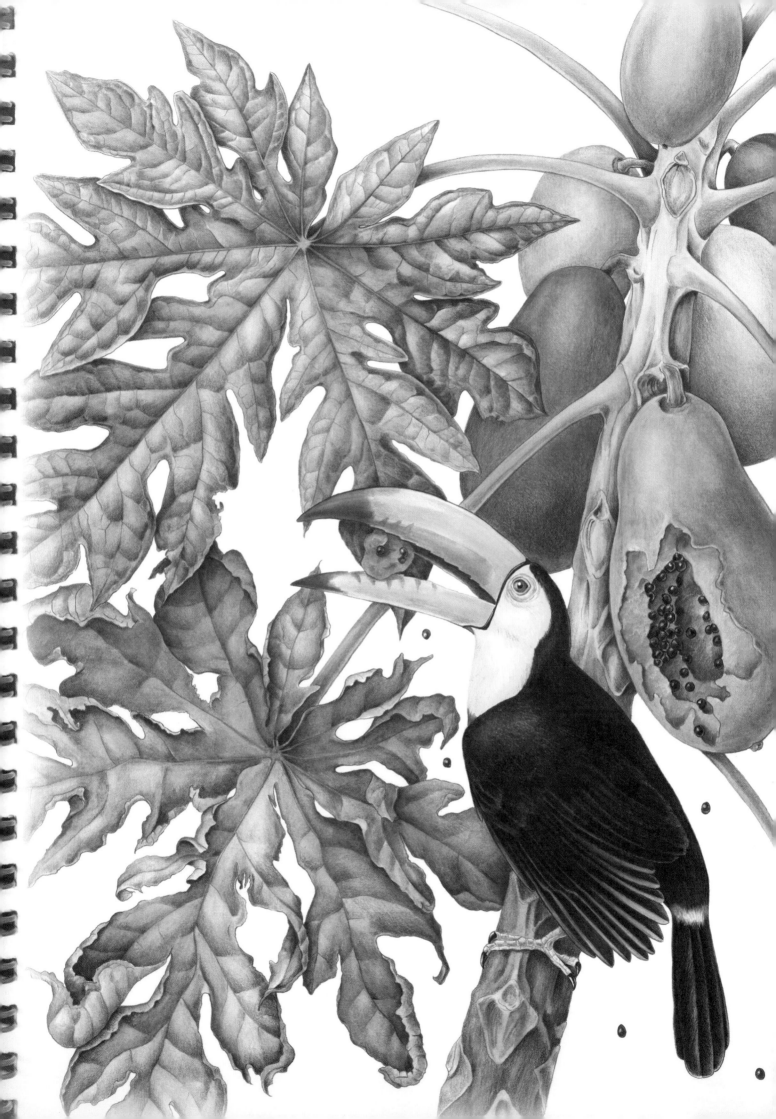

Great Horned Owls

Sometimes going for a short walk in nature can reap great rewards. I once came upon a pair of great horned owls raising their owlets in a "grand daddy" oak tree. These trees are also known as live oak, or *Quercus virginiana*. They are enormous and harbor many other species of plants that grow on the limbs. Over several weeks I returned many times to quietly observe the family. From this encounter, I began to compile photos and sketches of plants to incorporate into my painting. The owlets were tucked into a crook of the tree, and it was very difficult to see all the body parts. As immature birds, they are very fluffy.

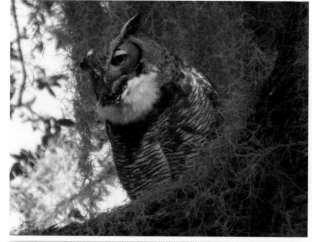

I decided to do this painting in a combination of graphite, gouache, watercolor, and pastel. Graphite is a great way to start a painting, because it is easily corrected. Textures and light source can be changed and manipulated at this stage. After transferring my rough drawing from tracing paper to 300-lb. hot-pressed watercolor paper, I began to redraw and refine all elements in the drawing. My final sketch is on page 125. This painting is horizontal in format (18" x 14").

Materials Used:

Graphite
HB sketching pencil
2H mechanical pencil
Paper stump or tortillion

Watercolor
Hematite
Hansa yellow light
Burnt sienna
Ultramarine blue
Phthalo blue
Perylene green
Quinacridone rose

Gouache
Titanium white
Black
Yellow ochre

Pan Pastels
Turquoise
Violet
Ultramarine blue
Titanium white

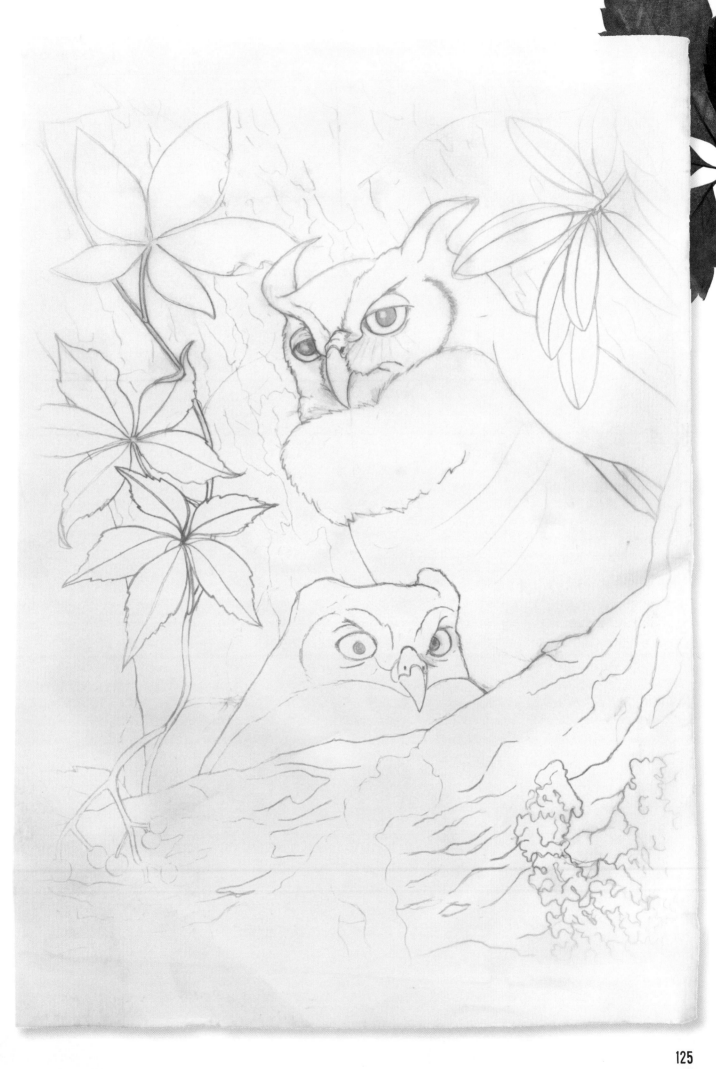

Tree Bark in Graphite

Oak tree bark is very textured. In this illustration, it encompasses almost half of the drawing. It's also in the background, and I prefer to start with the background and work forward. This is partially why I chose to begin with graphite. I used a large HB pencil lead holder to begin blocking in elements of the bark, working in the direction of the surface contour and light source.

The texture of the paper comes through the strokes. I wanted to be able to model the texture and undulate some areas to recreate the terrain of the bark. To do so, I used the point of a paper stump to get into areas behind the leaves.

After the areas were smoothed over, I used a 2H mechanical pencil with a very sharp point to go into areas and make the edges crisp and defined.

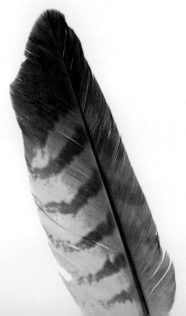

Spanish Moss

Spanish moss, or *Tillandsia usneoides*, is an epiphytic plant that often grows on oak trees. It can be found on the limbs of the trees and around the base of the trunk. It looks like a fine root system. To assimilate this texture, I used a handheld electric eraser to "draw," holding it like a pencil to achieve the squiggles and overlapping of the moss.

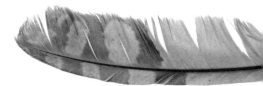

Once the white of the paper was revealed, I came in with the mechanical pencil and added heavier lines on the shadow (right) side of each strand.

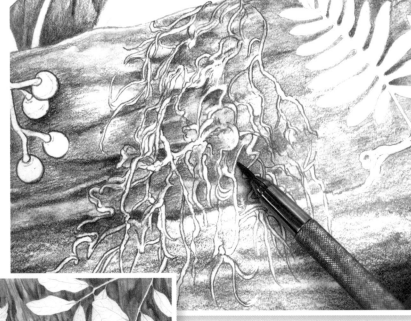

To finish the graphite portion of my illustration, I worked on the owls to get a general sense for how the feathers cover the body. I especially focused on the areas around the eyes to get a good understanding of the texture and structure before moving on to paint. The large white area is reserved for the sky.

Watercolor Overlay

With the graphite drawing complete, it's time for color. Hematite is a mineral found naturally, and its color ranges from black to steel or silver-gray, brown to reddish-brown, or red. Many watercolor manufacturers have created a paint using this mineral, and it's one of my favorites. When dispersed onto heavily wetted paper, the particles break up and granulate. The color and granulation was a perfect fit to overlay the pencil drawing of the bark. I started at the top and systematically worked my way down the page.

I wetted the area and dropped in a full load of hematite paint. In the areas where my drawing has lighter values, I used less paint. In the darker areas, I used more paint.

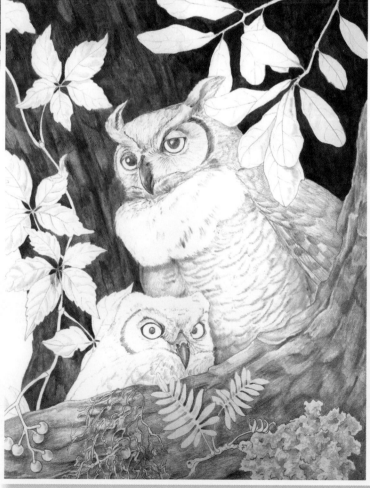

Lichen

Another thing that grows on the limbs of oak trees is lichen. Lichens are groups of organisms consisting of a fungus and an alga. They grow together in a mutually beneficial relationship. Colors may range from white to gray, red, green, yellow, or black. I drew the area in graphite and then wet the entire area. Using a mixture of greens, hematite, and white gouache, I used the tip of a round watercolor brush to drop in the colors. The heavy application of water allows the paint to mingle. I was careful not to create brushstrokes, but let the water move and meld the colors together.

Spanish Moss with White Gouache

When I painted the bark, I painted right over the Spanish moss. It would have been impossible to paint into every little nook and cranny. The basic nature of watercolor is that it is transparent, so the graphite drawing of the moss is still visible. I used it as a guide to paint the opaque white strands over the graphite and watercolor with a small, synthetic spotter brush.

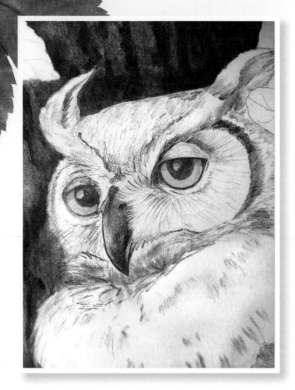

Owl Eyes

A lot of the background information has been blocked in, and now it's time to bring the painting to life. When painting any animal, be it human, bird, or cat, the best way to do this is to paint the eyes. I placed the large pupils of each owl in the darkest areas of graphite and left a white highlight consistent with my light source. I then created a medium-yellow mixture and an orange-yellow mixture. I placed the lighter yellow over the entire eye, including the dark pupil. Then I placed the darker orange-yellow just under the eyelids. This helps to show the eyelid casting a shadow over the eyes.

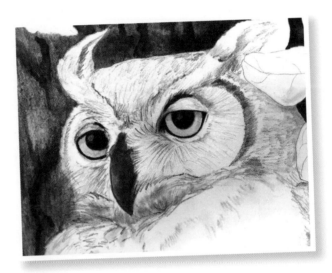

Black but Not Black

Black straight out of the tube can render the subject flat, especially black gouache. I used a vibrant layer of phthalo blue in the pupil area, as well as in the beak.

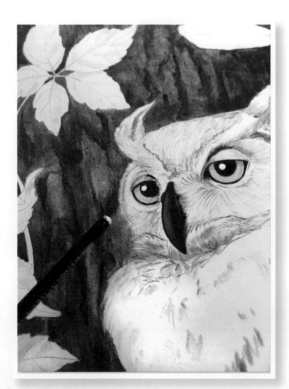

It may look strange, but the underlying color adds depth and "sparkle" to the finished painting. Next I layered black and white gouache over the beak, gently blending and alternating the black and white in a watery mixture to sculpt the beak and give it form. To finish the eyes, I took the handle of my paintbrush and dipped it into diluted white paint—adding water gives it a creamy consistency; it should be opaque but not too watery. I strategically placed the paint on the end of my brush in the black of the pupil to form a highlight with one quick dot—no fussing. I repeated the process for the owlet.

White gouache is always best used straight out of the tube. I find that reconstituting it after it has dried does not work as well. White also gets contaminated quickly. I squirt out small amounts often while I am painting, rather than a more substantial amount all at once.

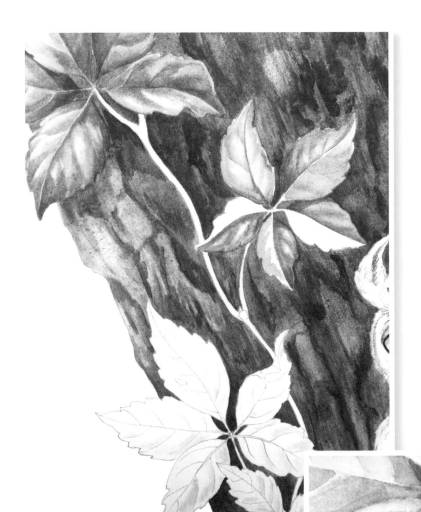

Virginia Creeper

Virginia creeper, or *Parthenocissus quinquefolia*, is often mistaken for poison ivy. It's similar in appearance and often grows in the same areas and conditions as poison ivy. The best way to tell the difference is to look for five leaves— poison ivy has only three. I have often seen Virginia creeper growing up the tree trunk of an oak tree and liked the addition of the purple/blue berries with the red stem. I mixed varying amounts of hansa yellow light and ultramarine blue to create a variety of greens. Even though only two colors are used to mix the green, I wanted to make sure there was variation to create interest. I covered all the green leaves in the composition, varying the greens and keeping my light source in mind.

I used a watery mixture of quinacridone rose to fill in the stem on the Virginia creeper vine, keeping the left side of the vine highlighted. I worked detail onto the leaves with perylene green, a very deep, almost-black green. I placed the lines on dry paper using a small spotter brush. Then I used clear water to blend and graduate the color, creating additional form and detail.

131

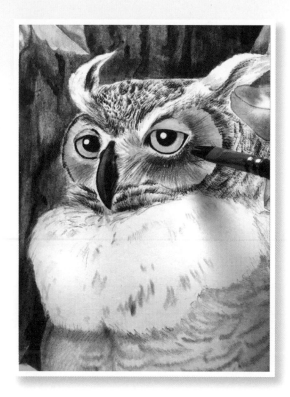

Contour Body Feathers

As discussed earlier, a bird is covered in contour feathers. The intricate color pattern on the body, wings, and head can be daunting. I think of it like doing a portrait of a person. You would never try to count the strands of hair on a person's head. The same is true for the feathers on a bird. The most important thing is to understand how the feathers come off the area and to follow the surface terrain.

The hair or fur-like feathers around the eye are known as the facial disc. They are concave and collect sound waves that go directly to the owl's ears. These feathers allow it to locate prey by sound alone. To quickly "map out" the direction of the feathers around the eye, I used a rake brush, which allows multiple strokes to be done simultaneously. You can use a small spotter brush, but it is more time consuming. I applied gouache, alternating burnt sienna mixed with ultramarine blue. The more orange the color, the less ultramarine added to the burnt sienna. The darker the brown, the more ultramarine added to the burnt sienna.

I painted all the feathers the same way for both the adult owl and the owlet.

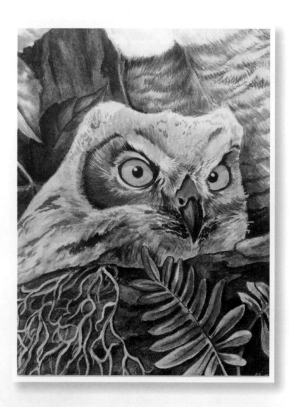

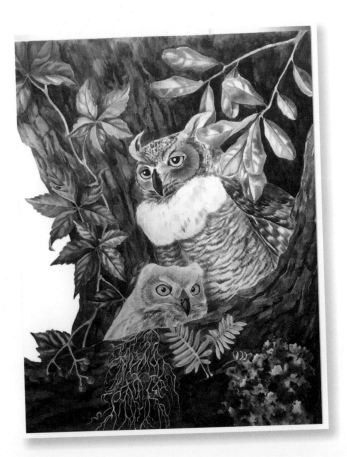

I introduced yellow ochre gouache in the painting and mixed it with white to achieve color variation.

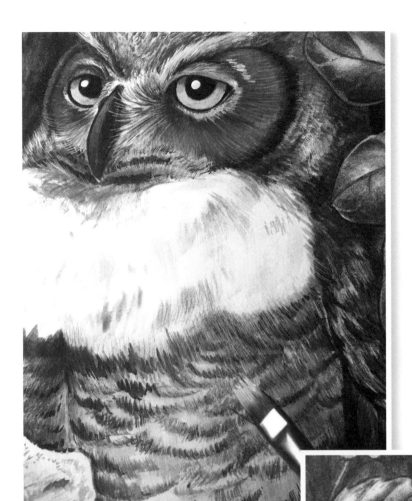

Breast Feathers Detail

Using the rake brush and moderately thin white gouache, I went over the pattern of the feathers to create small lines that blended one area into another. The appearance is more like soft fur, rather than bold stripes. As the breast moves and tucks underneath the wing, I added some brown in the same fashion to show the roundness and fullness of the breast area. I continued to alternate the layers until the areas were soft and mottled.

To achieve the soft, downy feathers of the owlet, I used a heavy consistency of white gouache. I overlapped the areas, so the owlet would appear to come forward in front of the leaves. The opaque nature of the gouache allowed me to do this. I gently patted the paint into the area to create the appearance of fluff.

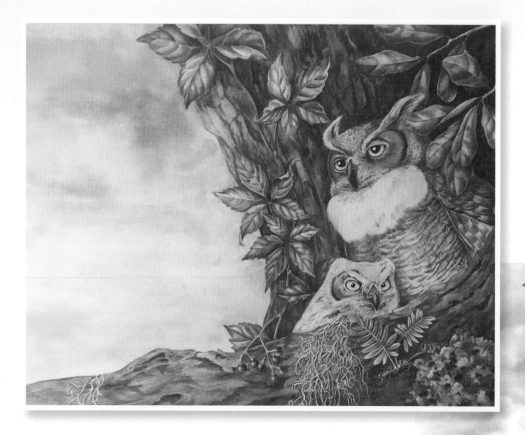

Sky

Florida is known for its beautiful clouds. I started by using a wide flat brush to wet the entire area. When I got to the leaves and tree trunk, I switched to a large round brush to get into the smaller angles. I continued to wet the paper so that it was evenly moist over the entire area. It's important to create the same moisture content over the entire area; otherwise there will be delineation lines, as well as blooms. I premixed a large quantity of watery phthalo blue and ultramarine blue and intermixed the paints on the wet surface, with the heavier color at the top of the sky, getting lighter as it neared the bottom. While the paint was still wet, I used a bunched-up paper towel to lightly blot some clouds. The paint lifted and left white areas where the clouds will be further developed. Then I let the paper completely dry.

Once the sky was dry, I used pan pastels for the clouds. I added darker colors at the base of the clouds and used white to blend the colors and integrate them into the watercolor sky. I used two application sponges: a wide broad sponge for large areas of color and a smaller applicator to get in tight areas to define the cloud edges.

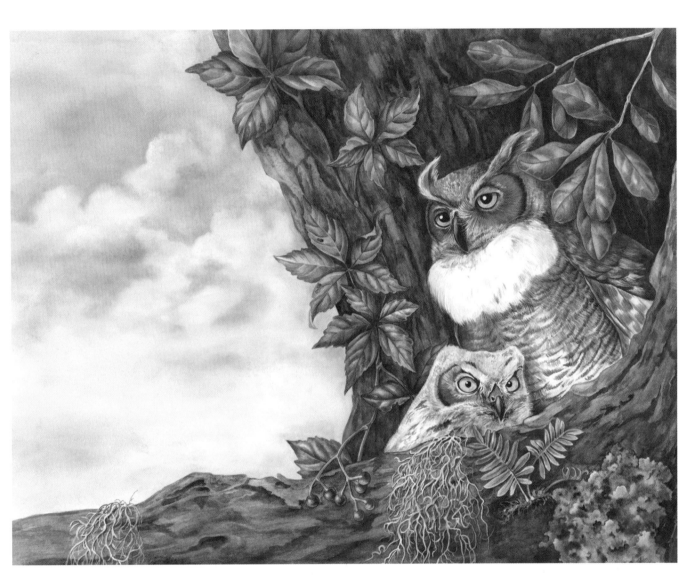

It's fun to combine different mediums in a painting. The key is making sure that it looks cohesive. One technique or application should blend into another to make the painting come alive.

Creating a Sketchbook

The best way to get good at drawing is to draw as often as possible. Creating a sketchbook is a way to record important information, learn more about any given subject, and hone your drawing skills. Develop your own style, and don't be afraid to experiment!

Getting Started

Get out into nature as often as possible, and start a journal today. Here's a page from my sketchbook that focuses on leaves found in my garden. They are native to the region where I live.

1. Go for a walk, and collect leaves.

2. Create rubbings of the leaves on tracing paper.

3. Cut out the rubbings, and place them in your sketchbook to determine the composition.

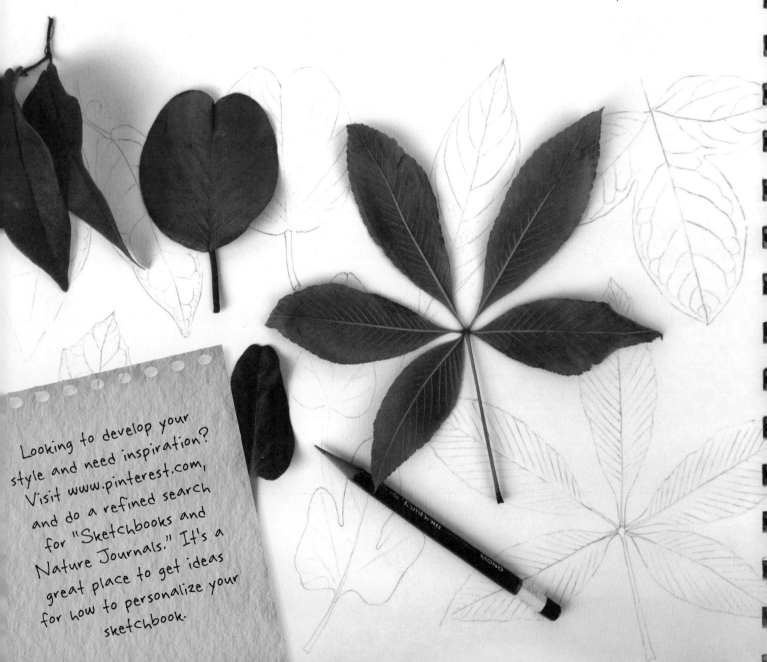

Looking to develop your style and need inspiration? Visit www.pinterest.com, and do a refined search for "Sketchbooks and Nature Journals." It's a great place to get ideas for how to personalize your sketchbook.

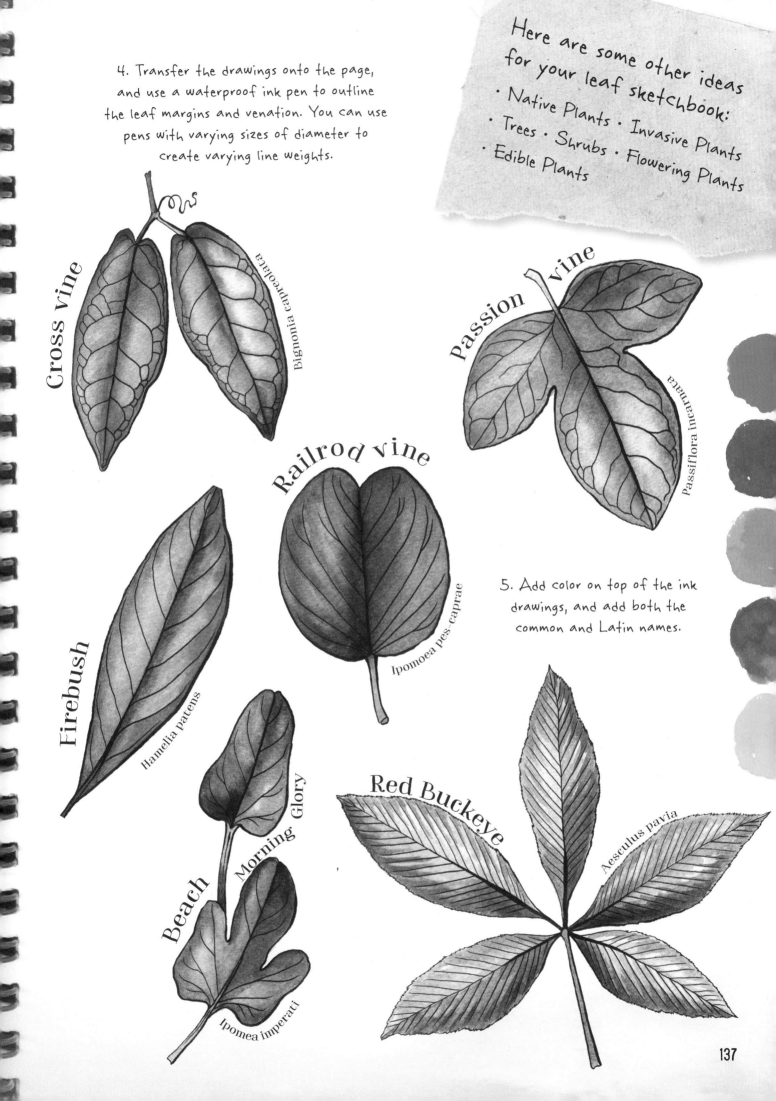

4. Transfer the drawings onto the page, and use a waterproof ink pen to outline the leaf margins and venation. You can use pens with varying sizes of diameter to create varying line weights.

Here are some other ideas for your leaf sketchbook:
- Native Plants • Invasive Plants
- Trees • Shrubs • Flowering Plants
- Edible Plants

Cross vine

Bignonia capreolata

Passion vine

Passiflora incarnata

Railrod vine

Ipomoea pes-caprae

Firebush

Hamelia patens

Beach Morning Glory

Ipomea imperati

5. Add color on top of the ink drawings, and add both the common and Latin names.

Red Buckeye

Aesculus pavia

Gallery of Finished Work

These are examples from my portfolio,
showcasing a variety of media and techniques.

Hummer Time, 14" x 18," watercolor on Fabriano Artistico Soft Press 300-lb.

This painting was inspired by my garden when I lived in New Jersey. The flowers are Siberian irises, and the little critter is a hummingbird moth. Each afternoon the hummingbird moths would come to my garden to feed. I thought they were tiny hummingbirds at first. This is what is called *mimicry* in nature. They act very much like hummingbirds; it wasn't until after careful inspection that I realized it was actually a moth. I used a wet-on-wet technique for the background and placed plastic wrap on top until dry. Once dry, I removed the plastic wrap, revealing the abstract background pattern. To preserve the white of the paper for the flowers and moth, I used masking fluid.

Harbingers of Spring, 14" x 18," watercolor on Fabriano Artistico Hot Press 300-lb.

The first signs of spring can inspire! One of the first trees to bloom in the Northeast United States is the magnolia tree. This is an uncommon variety, with blooms that are deep, dark plum on the outside and pale pink on the inside. I painted the branch with hematite watercolor. The mourning cloak butterfly is one of the first butterflies to emerge in the spring, because it overwinters as an adult. I decided to put the two together to celebrate the first signs of spring.

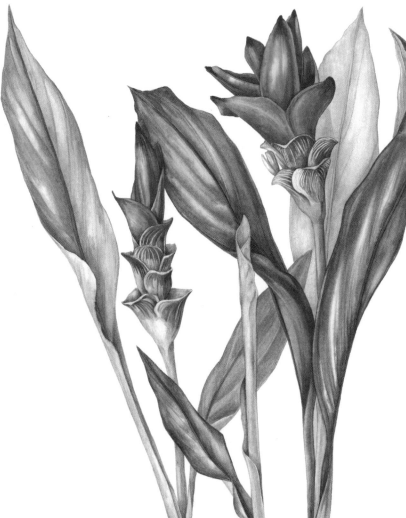

Siam Tulip in Magenta, 14" x 18," watercolor on Fabriano Artistico Hot Press 300-lb.

I found this beautiful flower at my local garden center! It comes in pale pink, magenta, and white. I was thrilled with the discovery, as I was able to purchase it, bring it home, and draw it in my studio at varying stages: bud to emerging bloom to full flower.

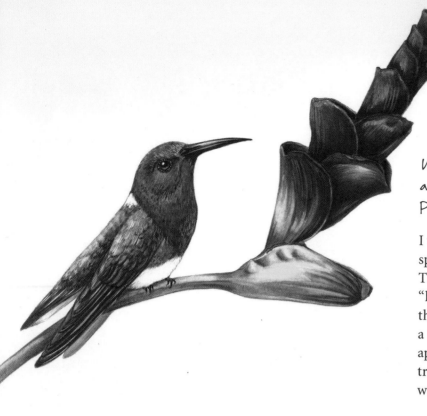

White-necked Jacobin, 14" x 10," graphite and gouache on Fabriano Artistico Hot Press 300-lb.

I visited a tropical garden in Costa Rica that specializes in attracting hummingbirds. The white-necked Jacobin is a medium-size "hummer." This flower is a type of heliconia that is pollinated by hummingbirds. I created a tonal drawing in graphite first, and then applied gouache on top, starting with thin and transparent layers and gradually working my way to more opaque layers.

Right: Spectacled owl sketch, 5" x 7," colored pencil on Strathmore drawing paper

Bottom: Toucan Rescue Ranch, 18" x 14," colored pencil on Stonehenge paper

While visiting the Toucan Rescue Ranch, a rehabilitation center in Costa Rica, I created this preliminary colored pencil sketch of one of their owls in quarantine. After my trip, I used my sketches and photographs to create this compilation of the animals they care for. This colored pencil illustration was used in promotional t-shirts and other products to raise money for their foundation.

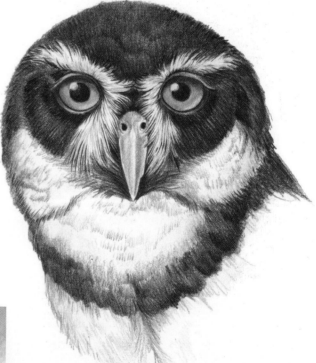

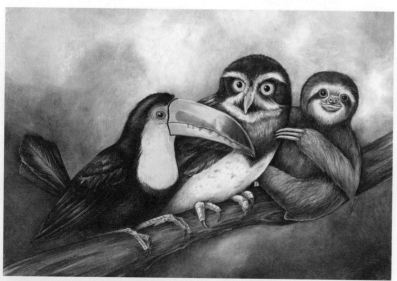

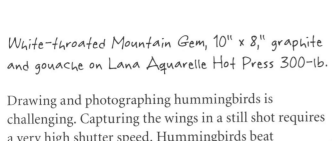

White-throated Mountain Gem, 10" x 8," graphite and gouache on Lana Aquarelle Hot Press 300-lb.

Drawing and photographing hummingbirds is challenging. Capturing the wings in a still shot requires a very high shutter speed. Hummingbirds beat their wings at an average rate of 50 flaps a second. This painting was done from a photograph I took in Costa Rica at a hummingbird feeder. The bird repeatedly came to the feeder, left to rest on a perch, and come back to the feeder. I wanted to capture the wings open, so I waited by the feeder and used the "burst" feature on my camera. This allowed me to take several photographs in rapid succession, which gave me enough information to draw from. I replaced the ugly plastic feeder in my photo with a beautiful heliconia, which is one of the birds' favorite nectar plants.

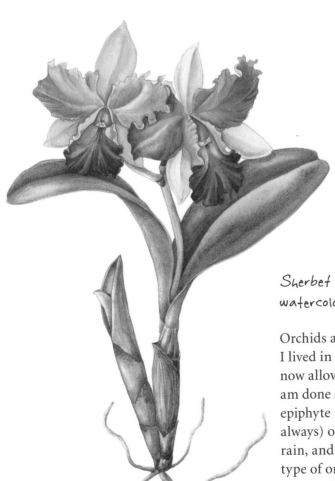

Sherbet Catelaya, 10" x 14," watercolor on Fabriano Artistico Hot Press 300-lb.

Orchids are everywhere in Florida! I tried growing them when I lived in New Jersey, and they always died. The climate I live in now allows me to buy the plants and put them outside when I am done drawing them. This type of orchid is an *epiphyte*. An epiphyte is a plant that grows upon another plant, mostly (but not always) on trees. It receives moisture and nutrients from the air, rain, and sometimes from debris accumulating around it. This type of orchid typically comes in a small pot filled with cork or coconut husks to anchor the plant from falling over and aerate the root system.

Artichoke, 8" x 10,"
pen and ink on double-frosted Mylar

Most botanical and scientific illustrations are done in black and white, because color reproduction is more expensive. I illustrated this artichoke in pen and ink using a dip pen called a crow quill pen. The beauty of working with this type of pen is that you can create thick and thin lines by varying the pressure with your hand. It takes practice and cannot be reproduced with a marker or technical pen.

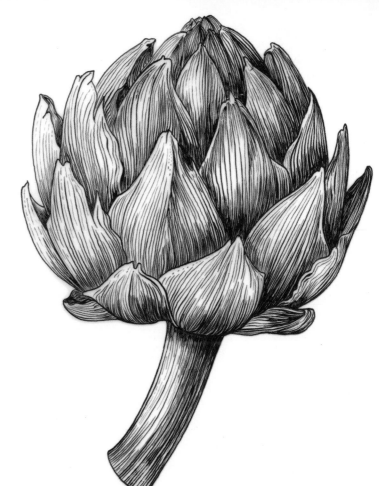

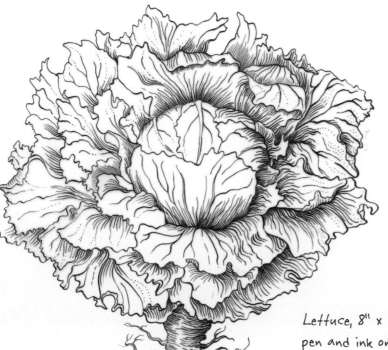

Lettuce, 8" x 10,"
pen and ink on double-frosted Mylar

I created this drawing with a crow quill pen in pen and ink. In traditional botanical illustration, it's customary to have a single element floating in space, which also showcases the root system. In this drawing, I combined thick and thin line work with stippling to create dimension and texture.

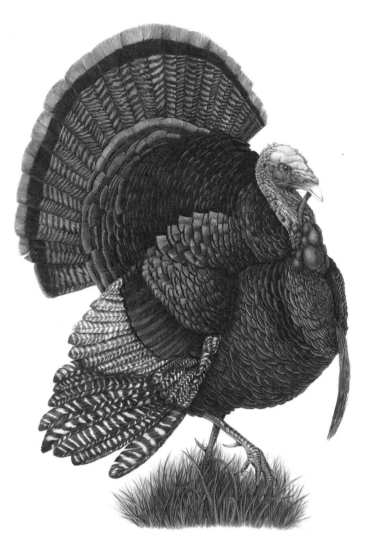

The General, 60" x 40,"
graphite, watercolor, colored pencil, ink, and
gouache on Lana Aquarelle Hot Press 300-lb.

This was one of my favorite and most challenging paintings. It was a private commission for a client of a five-foot male turkey in full strut. In researching for this piece, I used everything imaginable. I purchased the tail spread open, two wings, breast feathers, and the feet from an online retailer. I went to a local farm and was able to witness how the bird positions its wings, head, and tail as it walks. The breast feathers I purchased were not loose, but attached as a skin, which allowed me to bend the skin to see how the feathers separate. This helped me illustrate how light creates their iridescent quality. This illustration took me three months to complete, from start to finish.

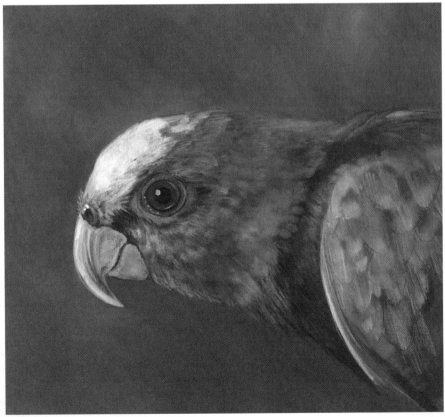

White-crowned Pionus, 10" x 8,"
watercolor, colored pencil, and pan
pastel on Fabriano Artistico Hot
Press 300-lb.

I created this small painting with loose washes of watercolor to block in color to fill all the white space. Then I used colored pencils to refine and add detail. To finish, I used pan pastels to create the background and add to the feathers to bring it all together. The key to working in mixed media is to have a cohesive, allover finished painting. If I had only used pastels on the background, for instance, and not on the feathers, the finished painting would look disjointed.

About the Artist

Artist Mindy Lighthipe is passionate about getting out into the natural world and discovering beauty in every rock, stream, and forest. With this passion, she carefully studies her subjects in their environment.

Mindy uses a variety of techniques and media to create her bold imagery. She paints in watercolor, gouache, colored pencil, and pan pastels. It's not uncommon for her to break traditional and classic rules by combining techniques to create her unique and breathtaking style.

Mindy graduated magna cum laude from Kean University with a BFA in studio arts and a MA in art education. She received her 210-hour certification in botanical illustration from the New York Botanical Gardens. After graduating, she went on to teach more than twenty different classes in their botanical art program and developed a 250-hour certificate in natural science illustration.

Mindy has been exhibiting her art since 1998 in juried and solo exhibitions. In 2009, she received a Silver Medal from the Royal Horticultural Society in London. In 2010, she had a solo exhibition at the Florida Museum of Natural History. Mindy currently teaches scientific illustration at the University of Florida. To learn more, visit www.mindylighthipe.com.

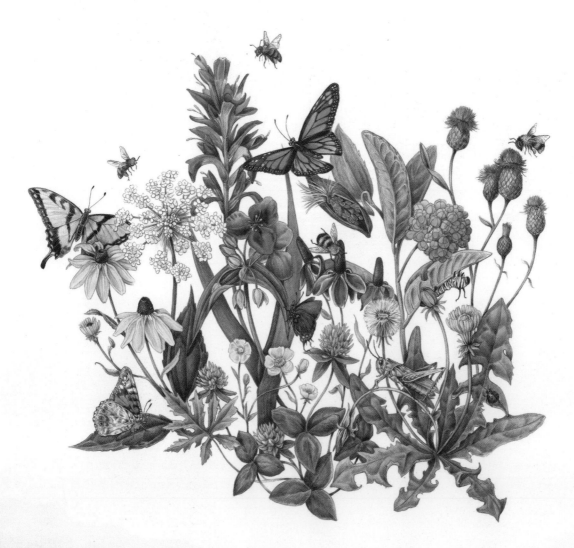

Roadside Weeds, 18" x 14", watercolor and watercolor pencils on Fabriano Artistico Hot Press 140-lb.